KU-004-202

GIFTED

PERSONALITIES
AND
TREASURES
OF THE
UNIVERSITY
OF
GLASGOW

GIFTED

PERSONALITIES

AND

TREASURES

OF THE

UNIVERSITY

OF

GLASGOW

•

Robert McLaughlan

FOREWORD BY

Sir William Kerr Fraser

MAINSTREAM
PUBLISHING
EDINBURGH AND LONDON

Copyright © R. L. McLaughlan, 1990

All rights reserved

The moral right of the author has been asserted

First published in Great Britain 1990 by
MAINSTREAM PUBLISHING COMPANY (EDINBURGH) LTD
7 Albany Street
Edinburgh EH1 3UG

ISBN 1 85158 375 0 (cloth)

No part of this book may be reproduced or transmitted in any form
or by any other means without the permission in writing from the
publisher, except by a reviewer who wishes to quote brief
passages in connection with a review written for insertion in a
magazine, newspaper or broadcast.

British Library Cataloguing in Publication Data
McLaughlan, R. L.
Gifted: Personalities and Treasures of the University of
Glasgow.
1. Scottish visual arts, history – Catalogues, indexes
I. Title II. University of Glasgow
709.411074

ISBN 1-85158-375-0

Designed by WIDE ART, Edinburgh
Typeset in 12/14pt Perpetua by Blackpool Typesetting Services Ltd, Blackpool
Printed in Great Britain by Butler & Tanner Ltd, Frome

Contents

BEGINNING AND BUILDING 9

ROMAN REMAINS AND ARCHAEOLOGY 19

THE COLLECTOR – WILLIAM HUNTER 27

ANATOMY AND PATHOLOGY 39

THE COIN COLLECTIONS 45

JOSEPH BLACK 53

ADAM SMITH 57

LORD KELVIN 63

THE HILL ADAMSON PHOTOGRAPHS 73

THE ZOOLOGICAL COLLECTIONS 81

THE PAINTINGS 91

WHISTLER 107

CHARLES RENNIE MACKINTOSH 115

SILVER 129

ETHNOGRAPHY 135

THE LIBRARY 143

Foreword

1991 MARKS THE 540th year since the foundation of the University of Glasgow. This may not be a particularly significant anniversary; but it seems appropriate, as the 1990 spotlight moves away from Glasgow as the European cultural centre, that we should remind ourselves and a wider audience that the University has a magnificent inheritance in the intellectual wealth of its associates and in the treasures it has received over the years.

In the following pages Robert McLaughlan, a graduate, Snell Exhibitioner, and former lecturer in Modern History at the University, looks affectionately at figures of the past and their surviving influence among us. Some, such as Adam Smith, are familiar names. Others – Henry George Farmer for instance – may be less well known. There are omissions – James Watt comes to mind – but this is not intended to be a comprehensive survey. Its approach is individual: a personal exploration of the evidence of the cultural past still to be found around Gilmorehill. The range is impressive – from pre-history to the present century through classical times and touching on every era in between. Illustrations are drawn from primitive and advanced civilisations alike, spanning all the arts and most of the sciences.

For several decades the University of Glasgow has had a special relationship with the Bank of Scotland and it is a particular pleasure to acknowledge our gratitude to The Governor, Sir Thomas Risk, and his colleagues for the enlightened sponsorship of this volume. They have made it possible to achieve a rich harmony between illustration and text.

Principal and Vice Chancellor

Beginning and Building

ITS LATEST historian insists that the University of Oxford "emerged" rather than was created. Glasgow University, by contrast, was the outcome of a definite act at a precise point in time. Moreover, given that we have tended to make abstractions even of our institutions (hence "the idea of a university") it may be interesting to note how Glasgow's origins were severely practical. Its creation in 1451 was designed to reduce the outflow of currency represented by Scottish students seeking academic instruction in Europe, and also to provide a nucleus of trained servants for church and state.

A rhetorical flourish associated Glasgow's foundation with the prestigious University of Bologna but more immediate and important influences were Paris, Louvain, Cologne and St Andrews, the latter being the first of a clutch of five medieval Scottish universities. This proliferation entailed a dispersal of national effort – and it might have been greater still, for Ayr, Perth and Fraserburgh almost had universities as well.

It has been argued that there were advantages from the diversity thereby conferred on Scottish higher education, but one effect of multiplying the institutions was to weaken their finances – Glasgow began its life in straitened circumstances without the revenues which would have ensured a more vigorous growth. Its founder, Bishop William Turnbull, and his successors, were unsuccessful in their attempts to remedy this want: their creation hobbled rather than ran forward.

This need not surprise us too much. Scotland in the mid-fifteenth century had a population of around half a million souls. Glasgow, though it had the cathedral and hence the bishop so vital to the University's origin, itself boasted only about 2,000 people, more village than town. Neither country nor town had access to the sort of riches which were to accumulate with New World trade, agrarian improvement and manufacturing expansion after 1707.

The early foundation was located near the cathedral. None of its buildings have survived any more than the first donations recorded as being made to the library, but from this period dates the splendid mace which was made in 1464 and survived a thirty-year sojourn in France (1560–90) before being returned. Its cost was something of an indulgence but it remains as a remarkable testimony to the

9

skills of its medieval Scottish makers. It may serve also as a fitting symbol of the ambitions of those who managed the first foundation.

For all its weaknesses the little university – sometimes attracting as few as ten new students a year – was not without scholastic distinction. John Mair or Major, who was Principal between 1518 and 1523, was certainly a considerable figure. He was a prolific writer, of history as well as theology, and a notable influence on others, especially the Protestant reformers, including Calvin. Major and "his circle" were logicians whose work, it has recently been claimed, anticipated the achievements of Frege.

Nevertheless, by the Reformation, Glasgow University was in dangerous decline and might easily have been extinguished. Royal and municipal property grants saved it and a fresh beginning was achieved by Andrew Melville, the Reformer who became Principal in 1574. Melville was instrumental in securing a new charter three years later and this *Nova Erectio* placed the University on a sound basis, bringing in the revenues of the parish of Govan to bolster its finances and providing a new constitution which did not receive a thoroughgoing reconstruction until the nineteenth century.

The seventeenth century witnessed a sustained programme of rebuilding financed by public subscription (Cromwell providing in 1654 the £200 promised by Charles I twenty-one years previously. It may be possible to see in that gap one hint of why the University, in the words of its later historian, always loved the Hanoverians!). These fine buildings have disappeared completely, at least on their original sites in the then city centre, but when the University moved to its present location on Gilmorehill, parts of the façade of the Old College in High Street were taken down, transported west and rebuilt as Pearce Lodge, a construct which is more interesting than convincing. Somewhat earlier a similar move brought the fine Lion and Unicorn staircases from the same place to its present position on the west corner of Gilbert Scott's main building.

These fragments confirm the impression of the earliest drawing of the Old College published in 1693: it was a handsome creation. A later plan of it survives (from 1857) and some earlier photographs; but by the 1920s insufficient precise data remained available to the University authorities to permit their commissioning the construction of an accurate scale model. However, an attempt was made half a century later when a model was commissioned for the exhibition to mark the 400th anniversary of Melville's new charter.

GLASGOW UNIVERSITY'S MAIN BUILDING

This view looks from Kelvingrove Park at the work of Sir George Gilbert Scott who also designed London's St Pancras Hotel. Scott believed the University owed much to earlier Scottish styles, but others have detected a definite Flemish influence. It certainly owes its physical materials to Gilmorehill since they mainly came from a quarry immediately to its west where the Western Infirmary now stands. However, the finishing and ornamental stonework had much more distant origins in Kenmure, Bonhill and even the Ross of Mull.

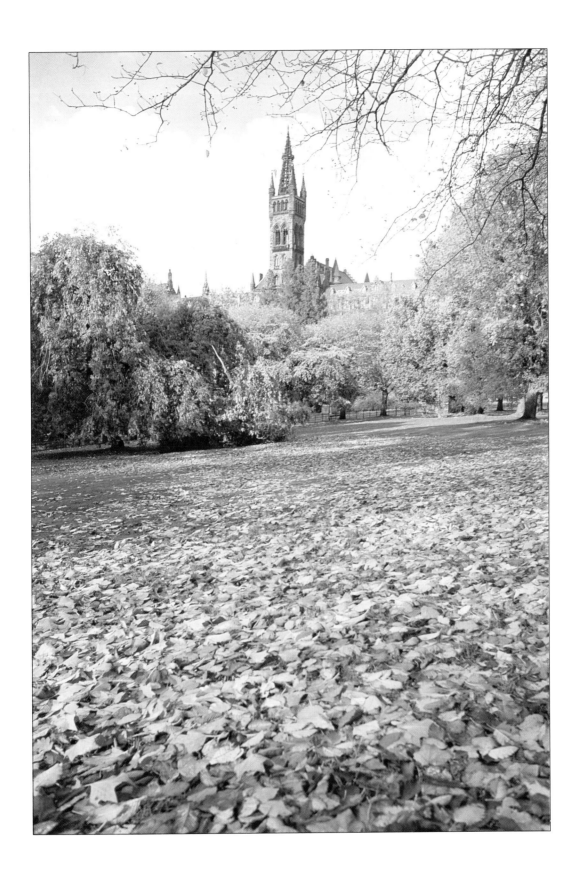

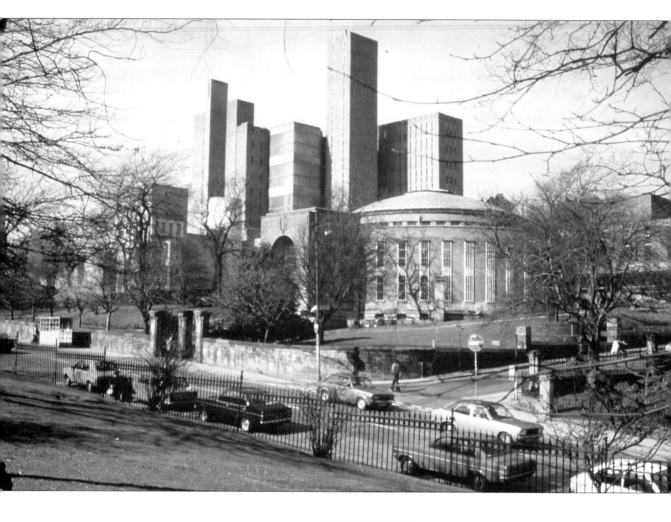

UNIVERSITY AVENUE
THE NEW UNIVERSITY LIBRARY RISING BEHIND THE HUNTERIAN ART GALLERY WITH THE OLDER
READING ROOM TO THEIR EAST

All are interesting creations. The Reading Room (1939–40), by T. Harold Hughes and D. S. R. Waugh, is
particularly appealing. The Gallery is something of a dream – at least to the non-expert. It is superbly lit but
natural light is automatically controlled to protect its exhibits. Its handsome wooden floors of polished elm show
something was saved from the havoc of Dutch elm disease.
Both Gallery and Library (1968–81) are one conception, by William Whitfield. The result is possibly Glasgow's
finest modern architectural creation (the Burrell gallery, curiously enough, must be the only contender for that
accolade). The Italianate towers provide an attractive skyline, something of a foil to the nearby Park Circus towers
and to Scott's open-work steeple, though they do not compete with the latter directly.

The eighteenth and early-nineteenth centuries produced a marked efflorescence of energy and intellectual inquiry in all the Scottish universities and a few names – Black, Hunter, Smith and Kelvin – will conveniently serve to demonstrate the scale of Glasgow's contribution to that movement and its continuing influence into our own time.

A somewhat similar, more physical, movement transformed the whole country, its landscape and economy. Scotland gradually derived enormous material benefits from the fuller Union with England in 1707 and the long period of domestic peace, stretching until the present day, which followed Culloden in 1746. The resultant private affluence was the vital background to the University's development in an age where large-scale public spending remained to be discovered but where the relative plenitude of places and the thirst for learning (and to "get on") drew in an unusual range of students, justifying the notion of "the democratic intellect", of which Scots were to be so proud.

The nineteenth century also witnessed the switch in the University's location from the area at the heart of the early city, around the High Street, to what would now be dubbed "a greenfield site" about three miles further west. The old foundation was surrounded by a particularly poor area "unfit for a great institution" according to the Superintendent of Police. His contemporary, Principal McFarlan, thought the daily scenes and the language which accompanied them were "injurious to the feelings, tastes and morals" of his students. This may strike today's students as lacking in robustness. A concern for their health might have been more appropriate given the overcrowding of the district.

The movement, however, conferred space on the University which otherwise would have been cramped. It may be dated formally to 1870 when the main building, which is probably the image of the University in the minds of all subsequent generations of students and teachers, was inaugurated. When everything Victorian invited suspicion, some noses were turned up at Scott's achievement. It remains, however, a triumphant statement of confidence especially when seen from the south-west, a romantic setting, where the effect of its soaring tower is redoubled by the plunging gorge of the Kelvin. From the upper floors of the new library its aspect is also attractive, the open work of the spire in particular conferring much pleasure from this view.

Scott, in his own words, "adopted a style which I may call my own invention. It is simply a thirteenth- or fourteenth-century secular style with the addition of certain Scottish features peculiar in that country to the sixteenth". The resultant Victorian Gothic may not be a perfect building – and doubters still debate the length against the height – but as time has passed the affection it inspires has been augmented by pride. Like much of Glasgow's Victorian architecture it has created the taste by which it is enjoyed and, with justice, is widely admired, a response also engendered by the work of Scott's son, the Bute and Randolph

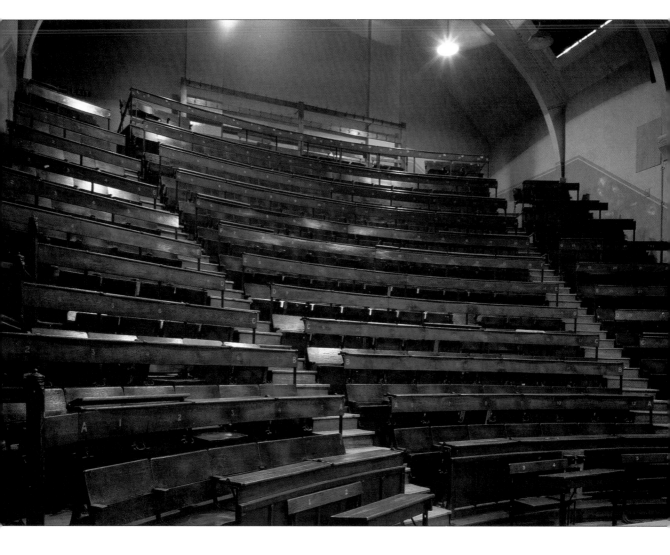

THE PHYSICS LECTURE THEATRE, 1907
Built to meet the requirements of Lord Kelvin, this theatre was finished in the year of his death. It may be what
many automatically assume to be the normal academic lecture venue but is in fact an endangered species – teaching
methods have changed, and such creations are fast disappearing everywhere. That, plus the fact that this is a
particularly fine piece of work, may yet allow its long-term survival as an historical artefact.

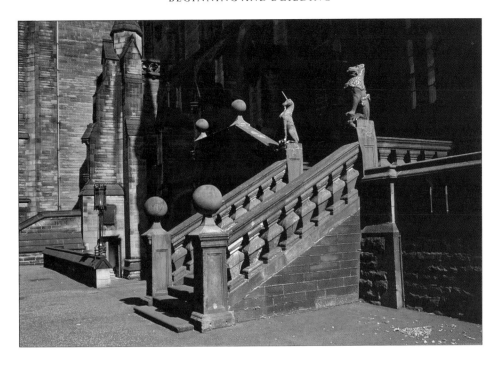

THE LION AND UNICORN STAIRCASE BY WILLIAM RIDDELL, 1690

Confidently assured and possessed of two splendid beasts, this staircase was also saved from the Old College. It was moved to its present site to provide an entrance to the main building from the Professors' Square which was also built by Sir Gilbert Scott. It jars a little with its Victorian surroundings but carries conviction on its own.

Halls. The very names are a reminder, if any be needed, of the immense role which private benefaction played in providing some of these buildings, but those who masterminded the switch also handled the University's own resources with a skill which later Scottish fund managers would not have despised. They also handled them with more public spirit than the early-nineteenth-century professoriate which freely spent the University's income on itself.

By modern times the state's role in funding the activities of all universities was predominant and government help was essential in erecting the most recent of the various buildings which now dot the area of Gilmorehill. Though Lord Esher felt that the impact of the University on Hillhead has been unfortunate in eating into its fine tenemented townscape, two of the erections there compel notice, the Reading Room and the Library. Both are fine buildings; the latter as poetic a work as Scott's although some changes to combat the onslaught of high winds reduced the impact of its vertical towers. The earlier Zoology Department building is also handsome; and if the Boyd Orr building does not command the same agreement it is certainly a very bold statement.

Not all of the Hillhead casualties of the University's almost inexorable advance

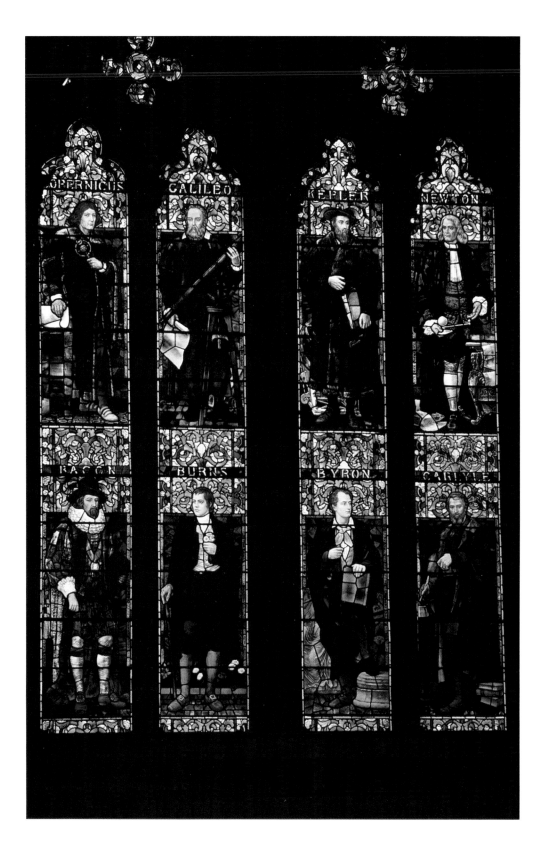

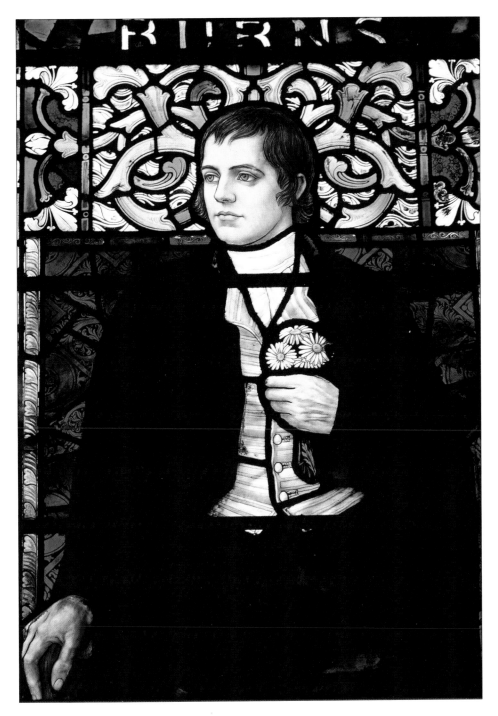

STAINED-GLASS WINDOW

Splendid stained-glass windows are a feature of the Bute Hall. Those portraying literary figures are, mostly, the
work of Burne-Jones and date from 1893. This is Robert Burns, the most celebrated of Scotland's poets and one
of the few in any language to have transcended both intellectual and social divisions in his appeal.
The remarkable displays of the stained-glass collected by Sir William Burrell, which are a feature of the gallery
built to house his collections, may encourage the closer inspection of these fine holdings on Gilmorehill.

northwards have been total. The new Hunterian Art Gallery affords a case in point. Financed from the University's own resources and widespread donation from private individuals and charitable funds, it is a worthy foil to the very different Burrell gallery in the grounds of Pollok Estate. It now holds Charles Rennie Mackintosh's Glasgow house. The original, a prey to fears of subsidence, came down in 1963, but a new perfect facsimile was built into the gallery, decorated and furnished as it was when the Mackintoshs lived.

Rennie Mackintosh is now an internationally renowned figure. Sadly, like Alexander "Greek" Thomson, Glasgow's other outstanding architectural talent, he built nothing for the University. His greatest work, the School of Art, about a mile further east, has become something of a Mecca for lovers of architecture. His qualities as an interior decorator and furniture maker are also now appreciated and their domestic impact is caught nowhere better than in his own apartments.

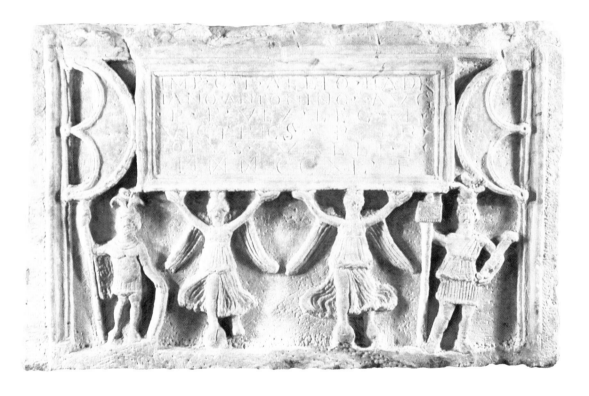

SLAB FROM BRAIDFIELD FARM, DUNTOCHER
This slab of yellowish-buff sandstone was found in 1812. The inscribed panel, held aloft by female figures, salutes the Emperor Antoninus and records that the legion involved – the Sixth Victorious – completed the rampart work over a distance of 3,240 feet.
The figures who hold this message are flanked to the left by a bearded Mars and the right by Valour, in the guise of an Amazon. Altogether a charming and satisfying work.

18

Roman Remains and Archaeology

NEARLY TWO thousand years ago detachments of three Roman legions (in total at least 6,000 men) built what we now call the Antonine Wall in deference to the then Emperor, Antoninus Pius. It ran along the line thought best to protect the central lowlands and conferring the best outlook to the north. The wall added its own fortification to the defensive qualities presented by the Clyde and Forth estuaries. Their effect was augmented by the river floors of the west-flowing Kelvin and the east-flowing Carron, above which the wall ran for thirty-seven miles. Its military capacities were enlarged, certainly at the western end, by separate fortifications on the southern side of the Clyde above Bishopton. There the river was wide but shallow and may have presented little obstacle to raiders debouching from the valley of the Leven.

The wall itself, an inward-sloping turf rampart on stone foundations, was fronted by a ditch and paralleled behind by a military road to facilitate the speedy concentration of manpower at its string of forts and fortlets. It was built in 142 AD, nearly a generation after Hadrian's Wall was begun.

The land between these two constructions had previously been abandoned by the Roman authorities, a confession that they could not easily maintain their rule anywhere north of what is now, approximately, England. The Antonine Wall represented a more optimistic assessment of Roman capacities. Nonetheless it was hardly long maintained: modern archaeological opinion accepts that the Romans withdrew again to Hadrian's Wall about twenty years after completing the more northern line.

These two fortifications are unusual in Roman history for although some other continuously fortified lines existed elsewhere in the Empire (in southern Germany, for example) the scale and completeness of the two British works make them stand out. Both marked the limits of Roman power and were designed to repel assaults on it. They would have had all the drawbacks of fixed fortifications at any time. The real defensive power of the Roman garrison derived from the mobility of the armoured infantry of the legions, but the walls prevented easy hostile incursions.

The Antonine slabs are themselves unique. Nothing similar now exists from any other Roman frontier except for Hadrian's Wall where survivals of a

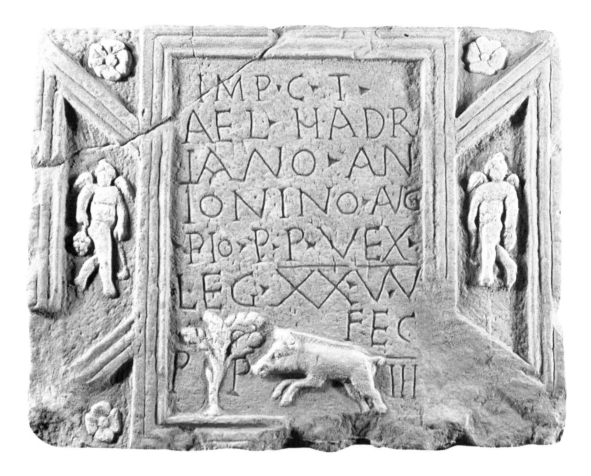

PLASTER CAST OF A SLAB FOUND AT HUTCHESON HILL, BEARSDEN, IN 1865
In the side panels naked Cupids carry a sickle and a bunch of grapes. Below, a boar, the symbol of the Twentieth Legion, runs towards a tree. The inscription records that that legion completed 3,000 feet of the wall. The original slab was taken to North America soon after its discovery and was destroyed by fire in Chicago in 1871. The somewhat austere design is attractive and, because it is only a cast, it has been painted to give some indication of what these slabs may have looked like when in situ and observed by contemporaries.

somewhat comparable nature are much less handsome and fall far short of the data the Antonine slabs record. Both walls were assertions of Roman might, advertising in themselves the enormous resources of an Empire probably far beyond the imaginations of the wild northern tribes who were certainly touched by its material civilisation and who no doubt longed to despoil it.

The advertising aspect of the fortifications was not confined to their direct visual impact in the case of the Antonine Wall. The message was reinforced for those actually living within the sphere of direct Roman power. On to the wall's southern face was inserted a series of large stone slabs recording the identities

of the military units responsible for their construction and celebrating visually several aspects of Roman might, especially military triumph.

These slabs seem to have demarcated the stretches of wall built by individual military units with one being placed at each end of a finished section of the whole. Each legion did not build a single long section of wall. It seems to have been planned in shortish sections and the various units leap-frogged each other as they finished particular sections. Their completion rates probably depended on forces as different as the varying difficulties presented by the local terrain and the military priorities at any given moment.

Originally there were possibly forty-two of the slabs. Only eighteen now survive. Another two were traced but have since disappeared again. Most of the preserved stones have been known to scholars for the past 250 years and no Roman artefacts surviving in Scotland have invited such continuous scrutiny apart from the wall itself. As early as 1768 some appeared in engraved reproduction in a Glasgow University catalogue. The University now boasts by far the greatest number of these surviving rare items. They constitute its oldest collection, excepting odd items in the library and some geological specimens. It is the only significant collection antedating William Hunter, an incidental aspect of these slabs which affords an innocent delight to those now responsible for their care and presentation.

That so many of the slabs survive at all seems to have been due to the deliberate care taken to ensure their preservation on the eve of the Roman evacuation of the wall. The records of some discoveries suggest that the slabs were not left to the attention of Roman enemies but were carefully buried close to their original locations. This considered policy of preservation might attest a Roman hope of future return or simply pride in avoiding the loss of face which would have accompanied the political demonstration of defeat entailed by their barbarian defacement or destruction. Not every slab was enabled to survive but it is still not clear that all survivors have actually been discovered – as late as 1969 one of these slabs was uncovered by a ploughman near Bearsden – though one known to have existed in the eighteenth century has disappeared long since.

The inscriptions on these slabs salute the Emperor and identify the legion involved in the construction work. In addition the length of wall built is noted, this measurement giving the stones the name – distance slabs – now commonly used for them. On two examples a somewhat more detailed description of the work involved is given – for example, building the turf ramparts – but generally the information is slight.

Were that all these stones were exposed their survival would still be interesting but hardly significant. The world possesses a rich heritage of Imperial Roman epigraphy. The distance slabs contain, however, as well as verbal inscriptions, sculptured scenes recording incidents from, almost certainly, the Roman

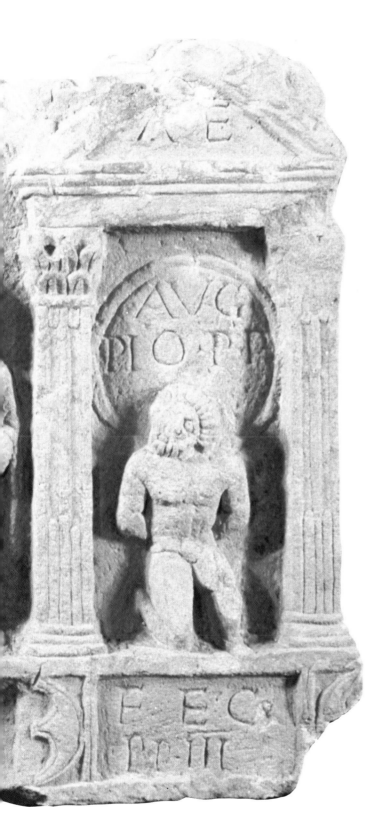

SANDSTONE SLAB FROM
HUTCHESON HILL, BEARSDEN

Discovered at Hutcheson Hill, Bearsden, in
1969, this handsome yellow sandstone slab
shows little sign of weathering. Its elaborate
carving possibly represents a triumphal arch-
way. On each side are kneeling captives. Under
the main arch a mysterious figure proffers a
wreath to the Eagle of the Twentieth Legion held
up by its aquilifer. The goddess Victory is not
usually represented wingless like this. Might she
be Britannia?

Altogether a particularly fine piece of work
which records how the Twentieth Legion com-
pleted 3,000 feet of the wall, the same stretch
recorded in the second slab shown above.

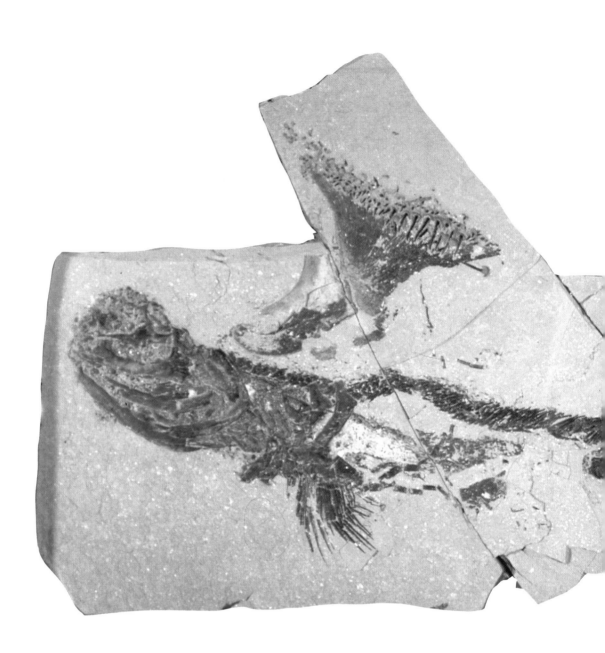

THE BEARSDEN SHARK

It may seem somewhat wayward to insert this remarkable item here, one of a very large collection of fossils in
the Hunterian Museum. It is the most complete specimen known of Strethcanthus, an extinct and bizarre fossil.
This example is male and still retains within it the remains of its last two meals. It swam in the then warm waters
of the west of Scotland around Bearsden 35 million years ago, where the Roman garrison built their own warm
baths.

conquest of lowland Scotland. They also portray ritual celebrations either preparatory to that campaign or attendant on its success. Surprisingly they proffer no pictorial record of the actual construction of the wall. They are not a whole series with a common theme – a sort of early version of the Bayeaux Tapestry but in stone – but they did have a common purpose in establishing a record and asserting Roman military prowess.

From odd traces of colour still remaining it is possible that their original visual impact was enhanced by paint. And from several general features and some particular details they can sustain a general line of argument about the extent of more positive interaction than war between Romans and Britons. The sculptors, uniformly and forever anonymous, were probably legionaries themselves according to Dr Lawrence Keppie, today's keeper of the slabs. Their work, even if in some cases inevitably coarsened by time's effect on sandstone, remains attractive. It discloses the influence of Celtic artistic modes as well as the more prominent Classical ones.

This is an important collection. The need to protect such Roman remains was first realised by the energetic William Dunlop, principal at the end of the seventeenth century. He provides an early example of the Appeal to the Alumni which many must think was invented by American universities. Dunlop toured those local landowners who were former students, and some who were not. He exhorted them successfully to donate to the University all Roman objects, including slabs, then known to exist in the environs of Glasgow. These had often been identified, and occasionally kept – as conversation pieces? – in big houses. Others have trickled in since, one after long service as a foot rest!

Such material is valuable for scholarly purposes but there has of late grown up an enormous popular appetite for archaeology (stimulated by some fine television programmes) and a wider audience now exists for such material. It might like to know that there are other archaeological "draws" in the Hunterian Museum, particularly of Scottish prehistoric remains. There is also a considerable fossil collection which records that, millions of years before Roman legionaries watched from the wall and refreshed themselves in the baths now excavated in douce Bearsden, enormous sharks swam in what were then tropical seas.

The Collector – William Hunter

IF, AS J. K. Galbraith believes, Adam Smith is "the greatest of Scotchmen" he ought to be run a close second by William Hunter, his contemporary. Only the diversity of Hunter's activities have obscured his significance, much as the differing locations of his various collections impede an assessment of their collective import. He himself was not blate in estimating his intellectual worth, putting his work on the lymphatic system on a par with Harvey's findings on the circulation of the blood. Just over two centuries after his death this personal judgement is receiving its vindication. His views on obstetrics, where he was one of the earliest proponents of natural childbirth, may command almost equal wonder; but Glaswegians can be forgiven if all such testaments of his worth take second place to his generosity in endowing them with so many collections of scholarly and material value.

William Hunter was born near East Kilbride in Lanarkshire in 1718. He was the seventh of ten children born into a modest land-owning family related to the Hunters of Huntershill. Two of his brothers, James and John, were to help him in his anatomical work; John, indeed, has even become the better known, certainly the better celebrated, since the Hunter Society takes its name from him and not William. It must seem doubtful if that ranking would survive a really scholarly examination of the pair (James, the third brother who dabbled in anatomy, died aged twenty-eight) but although there is a plethora of learned articles and several popular books on both there is no single work of sustained academic scholarship on either.

When fourteen, William was sent to Glasgow University. He was intended for the ministry but his five years study left him gravitating towards medicine. Hunter then resided in Hamilton with Dr William Cullen (later Professor of Medicine in the University) for three years. He also studied some medicine in Edinburgh before repairing to London in 1741 where, but for a single return visit to Scotland, he was to spend the rest of his life. Not even the entreaties of his dying mother whose favourite he had been could bring him back north towards the end of her life, though he long pondered the acquisition of a Scottish landed estate.

One historian has said that Hunter moved "crablike" into medicine, but in

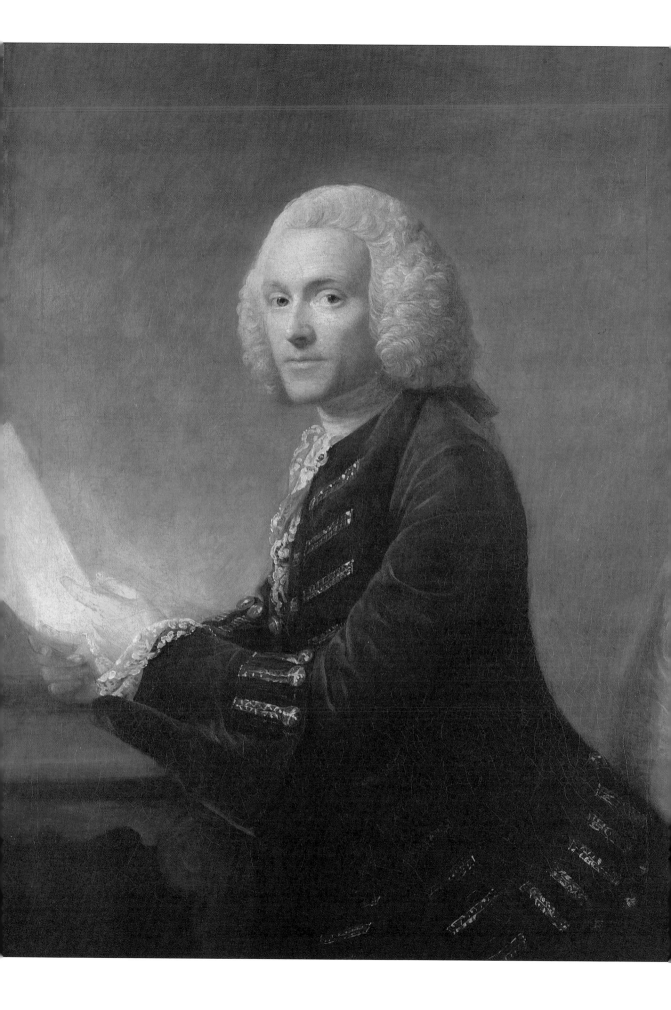

London a better metaphor is the ladder of social and professional contacts which allowed him to rise steadily to the top of the medical profession, particularly as an obstetrician where he became doctor-in-waiting to the Queen. It was as a man-midwife that he made his reputation, and much of his fortune. At the apex of his career he was able to charge consultancy fees of ten guineas, a large sum. His brother John suggested that William would not consider anyone who was unable to meet his fee, except in the case of established patients who continued to pay at the rate they had first been charged.

It seems unlikely that this income alone could have funded the various collections to which William Hunter devoted his wealth even allowing for John's opinion that he was "in the strictest sense, a miser". Helen Brock, who has produced the best succinct scholarly reassessment of William, came to the conclusion that he must twice have won the public lottery. This was the eighteenth-century equivalent of "the pools", and Hunter certainly had a chance of winning because he bought government stock to which lottery coupons were attached. His dabblings in such stocks as well as that of the East India Company, the only two tradeable savings instruments available at the time, do not support the conclusion that he was a notably successful speculative investor.

The lottery-win theory is plausible but cannot be clinched since, for the period in which Hunter was involved, the list of winners is missing; but Dr Brock who has scrutinised William's account with what was then Drummonds Bank (now part of the Royal Bank of Scotland) can come to no other conclusion. Whatever their origins, the two windfalls she has identified in his account, together with his ever increasing flow of personal professional income (over £10,000 a year by the 1760s), were put to good use in building a series of collections of ancient and contemporary material. Some of this (rare books, most of his paintings, coins and shells) had no obvious relevance to his professional career. Others were absolutely essential to it: the anatomical and pathological collections most obviously but some of his paintings as well, those by Stubbs in the Hunterian Gallery, and even his South Sea collection. The Stubbs paintings were commissioned by Hunter to illustrate rare animals, in one case the first of its kind to be brought to England. What are observed by us with eyes trained to extract pleasure were called into being first for purposes of scientific record, though

PORTRAIT OF WILLIAM HUNTER
Allan Ramsay (1713–84)
Ramsay painted Hunter sometime in 1764/5, and the result is one of a goodly clutch of fine works by this artist in the University's collection. It is a good portrait, suggesting a sensitive and humane personality rather than one tight and mean, though the line of the lips is very firm. That the two elements coexisted in Hunter seems evident, however; their friendship may have made the artist partial. The delicacy of the hands is of interest given Hunter's skill in dissection.

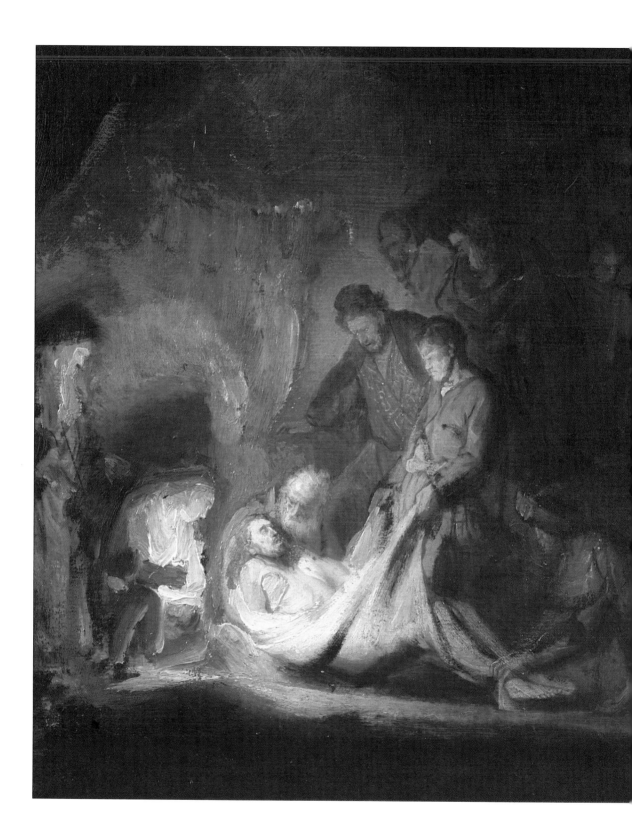

THE ENTOMBMENT

Rembrandt van Rijn (1606–69)

William Hunter's Rembrandt, oil on panel, may have been an early sketch for an upright painting with the same title, executed for Prince Frederick Henry of Orange between 1636 and 1639 and now in the Alte Pinakothek in Munich. If this is the case Hunter's version would date from the early to mid-1630s. It could, however, be a reconsideration of the same theme, painted later in the 1640s.

PANORAMIC LANDSCAPE

Philips Koninck (1619–88)

At a time when many "Rembrandts" have been exposed as not deserving of that description, Hunter's Rembrandt above gains a little additional interest from being genuine. This splendid Dutch landscape was originally bought by him on the assumption that it, too, was by the master. It is, in fact, by a pupil, Koninck, whose confident use of light and shade shows Rembrandt's influence.

no doubt Hunter had a shrewd awareness of the investment potential of these activities.

The fact is that he was interested in every aspect of Man and his place in the world. He may have, as has been suggested, been "buying culture" in his more aesthetic purchases – those paintings including his Rembrandt which formed the heart of the University's first collection of fine art – but a more genuine spirit of inquiry informed much of his accumulations. For example, he was quick to realise the significance of Cook's discoveries in the South Pacific and as smartly bought as many of the imported objects as he could easily lay hands on. His interest in comparative anatomy led him early on to be asked opinions of fossil remains from North America and in this area he certainly anticipated Buckland, just as in many respects he clearly anticipated Cuvier.

His main amassing of anatomical material always had a compelling practicality for in the early days of medicine such a collection was an essential teaching aid. Opportunities for dissection were relatively scarce, for though the practice was no longer entirely taboo, it was still suspect. A collection of specimens whose state and significance could be considered in a public lecture was a necessity to a doctor who was also a teacher. Hunter was both. Much of his professional income was derived from fees from students (though he paid a large proportion of these to his helpers, including his brother John). He ran what was in effect a private medical school; and two of his products later founded the first medical school in the United States.

Something of the contemporary significance of Hunter's huge anatomical collection may be gathered from the simple fact that its arrival in Glasgow near doubled the size of the medical school, as measured by numbers of students, within two years.

Hunter enjoyed such an outstanding reputation as a lecturer that his very success with the spoken word may go far to explain his comparative neglect in publishing his more scholarly writings. In a way which must strike us as curious, his long and detailed course of anatomical lectures exerted such a pull that many distinguished lay contemporaries flocked to hear him. In that number can be listed Gibbon, Burke, Adam Smith and Horace Walpole, though Burke was sceptical in one respect when he described what he heard as "political anatomy". Hunter's early political thinking had been Whig but was adapted to suit his Royal patron, and this seemed to have showed even in such an improbable context.

He had a suspicious and quarrelsome streak partly because at this stage in the development of the medical profession, practitioners, particularly those engaged in original research or the development of new procedures (and implements) were, usually, jealous of their own work and quick to resent its being passed off as others'. The idea of medical and academic achievement as part of a common pool for everyone's betterment was really slow to develop.

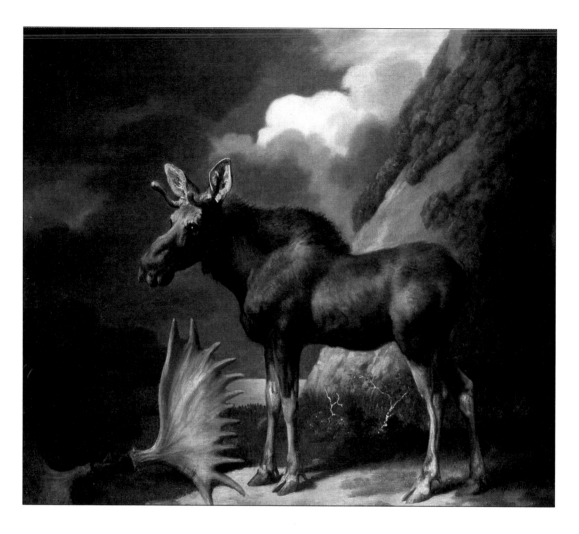

THE MOOSE

George Stubbs (1724–1806)

Of the four works by Stubbs in the University's hands, three came from William Hunter. Both William and John Hunter used Stubbs to paint rare animals, in pursuit of their studies in comparative anatomy. Before photography, this was the only way of obtaining a faithful record of unusual specimens, apart from taxidermy. This North American moose was acquired from Quebec by the Duke of Richmond in 1770.

Hunter used these paintings to illustrate public lectures – and claimed to have supervised Stubbs's work to ensure the fidelity of the reproduction. The outcome is certainly satisfying as a work of art.

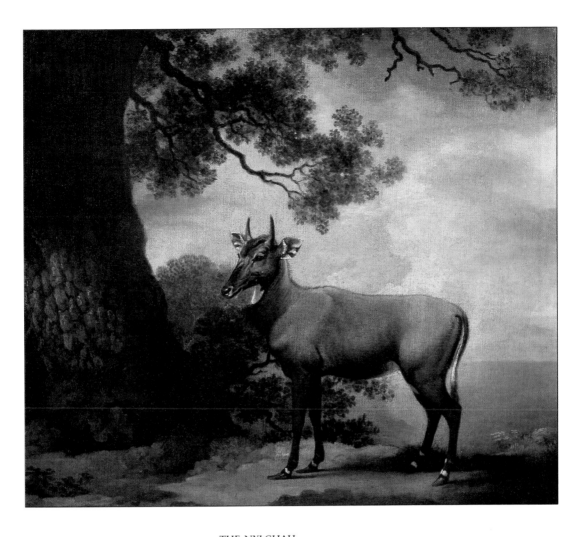

THE NYLGHAU
George Stubbs

A companion piece, and painted at about the same time (1769), this creature was one of a pair of rare Indian antelope which Hunter borrowed from Queen Charlotte. There is direct evidence that he used this painting as a visual aid to a paper he gave to the Royal Society in 1771.

Hunter's third Stubbs painting, not shown here, was executed between 1770 and 1780. The background remains incomplete, but the subject, a blackbuck, is interesting as an example of a rare Hunterian error – he wrongly identified the creature as a pigmy antelope.

William Hunter could have been a difficult man. He had some reputation as a wit, but Boswell, who was a good judge of speech and conversation, found him somewhat tedious. Another contemporary found him "glib" but those pronouncements which are preserved have a lapidary rather than concisely witty quality. Some may evoke a smile, but none a laugh. Horace Walpole, who was a friend, was apt to call William, "Goody Hunter", which does not sound admiring. And there is the strange fact that for all his reputation no members of the medical profession attended his funeral in 1783. Other collectors tended to regard him with mixed feelings, evidently discerning a predatory element in his interest.

William may also have been mean, particularly in dealing with his assistants, including John. The latter, however, produced a long series of annotations and additions to his own copy of an early admiring biography of William. These notes afford a generous personal estimate of William Hunter's worth and achievement: John was surely right to hail him as "the father of anatomy in this country".

He is bound to attract speculation for his activities were so varied and his motives, where they can be gauged, were seldom simple. He constantly escapes the neat pigeon-holes into which we are apt to place people much as if they were specimens themselves. Thus, in relation to women, some have been quick to dub William a misogynist, so explaining his failure to marry and, maybe, even his cruel disregard of his mother. On the other hand he seems to have been unusually kind to his sister. And there is his evident concern for the welfare of his female patients including his wise counsel on the minimal use of surgical instruments, like forceps, during delivery. This conveys a very different note; one confirmed by the fact that Hunter was well able to understand the mix of pressures which could lead new mothers to murder their offspring. He was also firm in refusing to divulge information concerning his female patients to their fee-paying, and occasionally sexually suspicious, husbands. The wells of compassion were certainly in him.

They are surely plumbed in his striking visualisation of mother and child in the *Human Gravid Uterus*, the most famous of whose plates has a powerful charge of aesthetic and clinical observation which makes it unique, certainly in its time and even now, for this material is still used in anatomical teaching and not just confined to library shelves. Of course Hunter did not make the engravings himself – and he seems to have treated the Dutch artist, Jan Van Rymsdyk, who did, badly – but he may have made, certainly closely supervised, the original drawings. Their detail in all its minute perfection is the work of the medical specialist who has to eschew the artist's licence. Hunter actually saw himself as being in a tradition of anatomical illustration going back to Leonardo. For all the fact that, as one commentator puts it, these plates "combine realism with butchery" there is certainly a "feeling" Hunter at work here; just as the dental

efforts of himself, and John, in extracting and then transplanting living teeth (for money, as satirised brilliantly by Rowlandson) reminds laymen of the unfeeling nature of much early medical activity.

Dr Brock has calculated that Hunter's total spending on his collections came to £100,000 or about £3 million in today's money. Not all the collections have survived (his herbarium of some thousands of plants was lost, swallowed up in Edinburgh's Royal Botanical Gardens) but they mostly have. Their modern value would be enormous, assuming that one could put a price on the unequalled anatomical material. It could be easier for items like the Rembrandt, for which Hunter paid £12, but it would be a tedious exercise. Enjoying – and exploiting – this material is far more exciting.

One interesting aspect of it is that it came to the University as much by accident as design. Hunter originally wanted his collections to remain in London and be taken under the Government's wing. He loved London but he also wanted state sponsorship for a museum which he would fill. In what must rank as a remarkable example of political myopia and penny-pinching he was refused. And that was Glasgow's gain, for it was only latterly that, in Sir George Macdonald's words, he "remembered the ground from which he was digged". His memory may have been jolted by his friend Samuel Johnson. He left all his material, and £8,000 in cash, to the University though it was first to be at the disposal of his surviving assistant, William Cruikshank, and his nephew Matthew Baillie. They permitted its passing to the University in 1807 and it came north in some style, escorted by the Royal Navy at sea or accompanied by what our time would recognise as private security guards by land.

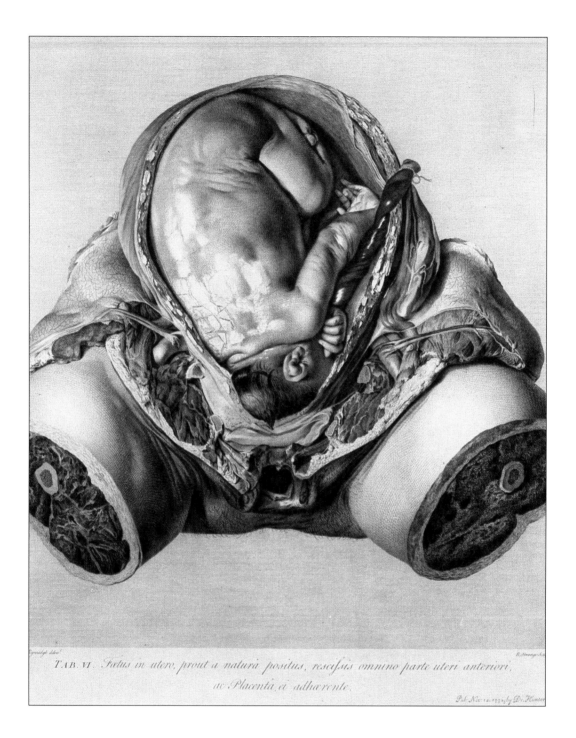

TAB. VI. Fœtus in utero, prout a naturâ positus, rescissis omnino parte uteri anteriori, ac Placentâ ei adhærente.

THE HUMAN GRAVID UTERUS

This is one of the magnificent plates from William Hunter's great work. It is a deeply-moving, poignant image. The dissection, even now, seems astonishingly perfect. Hunter may have claimed too much for his own role in this plate, but he certainly supervised the Dutch artist, Jan Van Rymsdyck, whose work it is.

Anatomy and Pathology

IT WAS AS AN anatomist that William Hunter made his popular reputation. And it was popular because his gifts of presentation and verbal delivery ensured a large audience whenever he lectured. Given everyone's fascination with their own health, it should not be surprising that interest extended far beyond the ranks of contemporary medics and students. But there was more to Hunter's appeal than that. He was able to demonstrate the various components and functions of the human body by displaying the bits and pieces his work allowed him to accumulate. What he eventually achieved was the largest anatomical collection in the world, and one which has never been surpassed.

At that stage in the development of medicine a battery of specimens was essential to teaching. They were visual aids certainly but their function was even more important in the days before every medical student was able to engage, often easily and directly, in dissection for himself. Hunter avidly bought in collections. He inherited that of James Douglas, one of his mentors and a distinguished anatomist himself, and he used his large income to buy up others when they became available as the consequence of the death of the original collectors. (He benefitted from the fact that early death was a common feature of eighteenth-century life, even among medical practitioners.)

He employed skilled assistants, including his own brother, and it is impossible to identify the work of individual hands in the mass of material he eventually assembled. Apart from the collections of outsiders, however, he supervised all dissections himself and was a superb proponent of the techniques required. John Hunter, highly gifted in this field himself (his own collection was mostly lost in the London blitz), gave the palm to his brother. The quality of William's work has now been long tested by time and continues to excite admiration among today's professionals in the field, who are not beyond calling for its pictorial use in furthering their own work.

His anatomical and pathological collections are now housed in two separate locations, at Gilmorehill and the Royal Infirmary (and they have been reinforced by the accumulated material of generations of outstanding anatomists in the University since 1807). The pathological specimens retain their role as teaching aids though the contemporary teaching of pathology depends mainly on

THE MERMAID
At first engaging, this little specimen of a human abnormality in which the lower limbs are fused, evokes feelings of intense sadness. It is one of a huge number of abnormalities collected by Hunter, although this has no direct provenance. The skin and tissue were detached from the skeleton and treated by a taxidermist, but the skeleton survives to show the underlying fusion that has given this exhibit its nickname.

microscopic techniques. Most disease is first manifest as cellular change, and tissue diagnosis is what is required. The appropriate slides can be blown up and shown to student audiences on a television screen, a far cry from Hunter holding aloft a specimen bottled in one of his well-devised preservatives.

All the modern techniques are utilised by the Department of Pathology at the Royal Infirmary but the teaching is in a suite of rooms which also houses the Hunter and the later collections in special cases with sophisticated lighting systems. The material displayed remains available for teaching purposes, and the result has prevented the museum from becoming a dead collection, of historical interest only. That applies also to the material housed at the Department of Anatomy on Gilmorehill, and there too the original Hunterian collection has been added to over time.

It is actually still possible to examine tissue from Hunter's exhibits micro-scopically, and in the case of unusual abnormalities there is every possibility that advances in the methods of investigating DNA will eventually add a new focus of interest to this particularly rich area of the collection.

It may seem unusual that a collection whose largest component goes back to the late eighteenth century might still be relevant to modern medical study. In some ways, however, the very success of contemporary medicine has ensured that this is so. Some conditions, some diseases, common in Hunter's time, and indeed much later, are now relatively rare – almost a matter of history. TB and its consequences provide a quick case in point. In addition, treatment would now avoid some of the conditions – enormous stones in the kidneys or bladder, for instance – with which earlier doctors (and their patients!) had to cope, and which are profusely present here. Their dimensions would certainly stagger the popular imagination but even professional observers of such examples are bound, some-times, to be taken aback.

Hunter's specimens often therefore show a degree of progression in disease which would be rarely present now. They also contain examples of a wide range of mammalian abnormality. In the case of human beings every kind of foetal abnormality is represented, something which might have been expected from Hunter's own interest in midwifery. But other interests are also well repre-sented. For example, in the case of skeletal development, whereby cartilage pro-gressively becomes bone, William was able to assemble a long progression of specimens from children up to the age of six. These show the process with the same certainty as a cine film, though without its speed. It would not be so easy to assemble a comparable series nowadays when, fortunately, death at an early age is far less common than it was in Hunter's time.

This is not the sort of material generally to excite laymen but for anyone with a medical training or interest it is obviously fascinating. (The fascinated will not only be doctors: both Hunters engaged in dental work and the dissections in

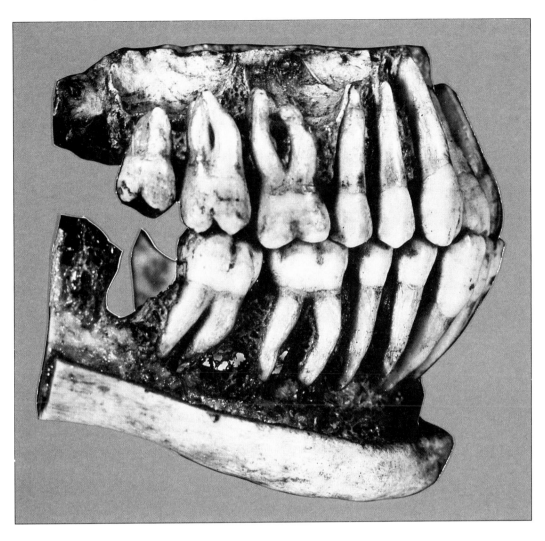

HUMAN JAW AND TEETH

Both Hunters engaged in dental work and in the lucrative transplanting of teeth from healthy but poor people to dentally less fortunate but rich clients. Their dissections of the jaw, teeth and associated musculature have continued to evoke admiration from their own day onwards. The teeth missing from this jaw were probably missing when it was originally dissected and preserved, probably by William Hunter himself.

this area are particularly fine.) Because of their precise professional focus both the museums holding this material are not open to casual viewing by the general public. No seriously interested person would, however, be denied access to these collections, which must be just as well since the Royal Infirmary houses alongside its pathological suite some important relics of Sir Joseph Lister.

Lister was a pioneer of modern surgery. He may well be better known to popular opinion today than someone like William Hunter, for few medical men have had such a dramatic impact upon mortality. In the latter half of the last century, Lister's discoveries massively cut the death rate after surgery; and opened up many new areas of the body to successful surgical intervention.

Lister became Professor of Surgery at the Royal in 1861. In the middle of that decade nearly half his amputation cases died from sepsis (from post-operative bacterial infections). Lister almost anticipated Pasteur: he certainly took the first essential steps to combat bacterial infections though he did not know the exact nature of the forces he was working against. His first moves, using carbolic acid, were begun in the Royal – and reduced the mortality in amputation cases from nearly half the patients involved, to fifteen per cent.

His vindication really came in the Franco-Prussian War when German experiments with antisepsis saved many lives; but the generality of British medical opinion was slow to be convinced until after 1877 when Lister became Professor of Surgery at Kings College Hospital in London. The evident success of his work there soon swept the board, to everyone's benefit. The small University collection concerning him celebrates a justifiable pride in the origins of his work. Some of the Lister material is also maintained at the Hunterian Museum on Gilmorehill and this may be the most convenient location for popular enthusiasts.

The Coin Collections

IF THE TWO FINEST coin collections in the United Kingdom are in the British Museum and the University of Oxford, Glasgow can plausibly claim to have the third. The British Museum, which gained the magnificent Royal Collection from George IV, is uniquely placed both in status and access to money to maintain its supremacy. Oxford's coins represent the amalgamation of the college collections with those of the Ashmolean. Glasgow's coin holdings, however, still stem mainly from the huge collection, more than 30,000 strong, bequeathed to it by William Hunter in 1783 and received in 1807.

The greater part of the Hunterian collections were shipped from London to Glasgow under naval escort (the Napoleonic Wars were still raging) but the coins could not be so risked to the hazards of the waves, never mind war. They came north by road accompanied by six armed guards and were deposited in the Hunterian Museum in the Old College, a building specially constructed to house all the collections, much as they had been in Hunter's London house at Great Windmill Street near Piccadilly.

The original collection was felt to be much too valuable to be left on public view. It was held under lock and key – with three different keys in the hands of three separate professors, all of whom were required to be present whenever access to the cabinet was necessary. In fact the coin cabinet seems to have been subject to serious theft only once in its history. In 1837 a dozen Greek coins were stolen. There was a more modest attempt at pilfering later. A much more serious threat came from the suggestion that its sale could have funded the University more securely before and during its move from High Street to Gilmorehill. Indeed in 1858 the Report of the Universities Commission mentioned the coins as the sort of item which might have been sold (or given to the British Museum) as a prior condition of a public grant to the University. A similar proposition was advanced by the Report of the Scottish Universities Inquiry Commission twenty years later. It was as well that the University did not actually own the Hunterian bequests: they are held in trust by the principal and thirteen of his professorial colleagues.

In size the coin collection has almost doubled since Hunter's donation, and is still being augmented by judicious, if modest, purchases. It was considerably

reinforced by the Coats and Lockie collections. The first was presented in 1924 by the family of Thomas Coats of the Paisley cotton firm (now Coats Viyella). Coats had formed a superb collection of Scottish coins but these were given to Edinburgh's National Antiquities of Scotland Museum. What came to Glasgow was his classical, medieval and modern collections which neatly complemented and extended Hunter's range.

The Lockie collection had a similar impact. It came in over the years till 1974 when the collector and donor, J. R. Lockie, died. Mr Lockie was the authority on Scottish communion tokens in which, as the result of his generosity, the University is now rich. He also had many trade tokens and more modern British and foreign coins. These additions serve to illustrate a steady stream of donation which continues to the present day.

Sometimes the process produces splendid material historically as well as visually, like the group of some 500 coins from Carthage which were obtained by a Rear-Admiral of the Royal Navy serving in the Mediterranean in the early part of the last century. This group has gold and silver coins from Punic Carthage itself but also coins from all the later occupations, from the Romans through the Vandals, Byzantines and Arabs to the Tunisians. It was "lost" in a solicitor's office for nearly a century and presented to the University recently. Sometimes single coins have been found on sites excavated around the Antonine Wall and there have been odd purchases of hoards found as treasure trove.

To lay observers, coins may not be the most exciting objects of the collector's passion. Yet anyone in doubt of the visual impact delivered by a display of gold coinage might look at the Roman and Greek gold which Hunter acquired on a considerable scale. In quantity and quality this clutch is unique in the United Kingdom – there are about 1,500 items of Imperial Roman gold without duplication. Some is on permanent view where it may serve as an initial impetus to realise why these objects, even when of baser metals, exert such a pull on both imagination and intellect.

Hunter was certainly seized mightily by coins and any lingering suspicion that his motivation is explicable only in terms of miserly compulsion needs to be countered by reference to his willingness to allow his treasures to be seen by others and catalogued so as to be available for reference, and the scholarly effort he put into identifying and classifying them. Savant rather than dilettante must apply to him in this field.

He had a triple focus on Greek, Roman and British coinage with some especially fine Scottish items. He widened the scope beyond these even to include medals, medallions, tokens and, in one case, what might be termed curiosities with a monetary significance – Roman brothel tokens dating from the reign of Tiberius of which the holding is one of the largest in the world.

Between 1770 and his death thirteen years later, Hunter spent about £23,000

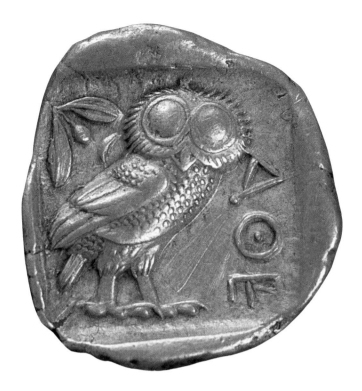

TETRADRACHM

This high-value Athenian silver coin of the fifth century BC depicts the owl, the symbol of the goddess Athena, portrayed herself on the other side. Athens derived much of its power from its silver mining and its coinage was widely used to finance trade in the Eastern Mediterranean. Because of this, the design of these coins remained stable for some centuries since changes might have made them less acceptable as a trading currency. The quality of this example, however, suggests a relatively early minting.

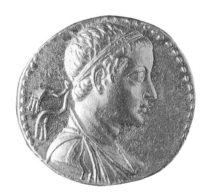

PTOLEMAIC HEAD

One of the superb series of Ptolemaic heads bought by Hunter from the Scottish explorer Bruce, a rare occasion when the great collector managed to trump the buyers for the French Royal Collection.

ROMAN PUNIC COIN

The oath-taking scene marks the first Roman gold coin struck during the Punic Wars, almost certainly as an emergency issue to pay the armies raised to oppose Hannibal's invasion of Italy in 218 BC. Gold rather than silver was likely to have been chosen since the higher value literally reduced the weight of coinage required by paymasters.

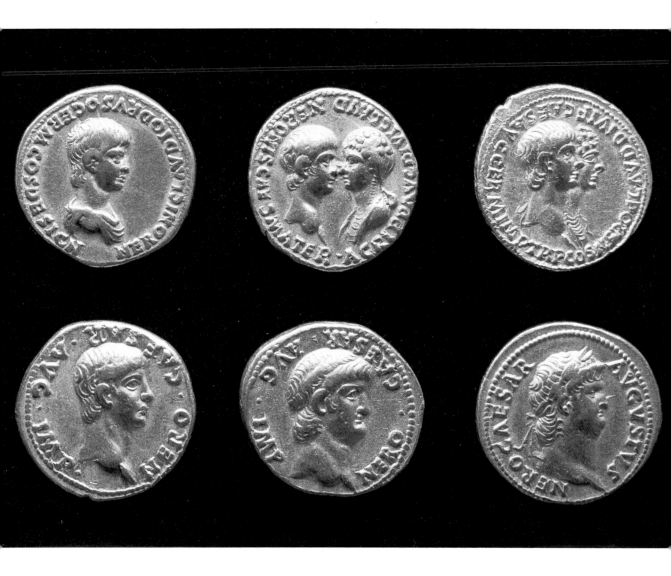

CLUTCH OF IMPERIAL ROMAN GOLD COINS ILLUSTRATING THE CAREER OF NERO
This clutch displays well the inherent political role of coinage as well as the Roman insistence upon factual rather than symbolic or idealised representations of the ruler. Nero not only ages, he deteriorates. The first coin shows the child Nero just after his adoption by Claudius. It proclaims his right to the succession. The next displays the boy with his mother, Agrippina, after Claudius's death: it mirrors the political reality of Agrippina's dominance. The third shows that dominance replaced by Nero's, but with Agrippina's influence continuing: his bust is superimposed on hers. With her death Nero is alone on the fourth coin. Its two successors show him progressively older and more gross.

buying coins, though he recovered as much as £2,000 odd from reselling what he considered duplicates. In that connection he had very rigorous tests so that every variety and genuine deviation, apart from the inflictions of usage and abusage, was considered a unique coin fit for the collection. This view caused considerable anguish in the case of one seller who had offered Hunter the pick of his own collection on the understanding that he returned all duplicates. Few were returned and the seller felt he had, literally, been short-changed. That example illustrates the ruthless aspect of Hunter's business dealings. He was equally capable of being hard on a friend who had bought him some items at too high a price. Sir William Hamilton, a sort of "scout" for Hunter in Italy, was much out of pocket when Hunter, valuing a collection Hamilton had bought on his behalf but not with his authority, found it to be worth much less than the unfortunate man had paid, and docked him of the difference.

Hunter's technique was not so much to search for single coins but to buy existing collections and then discard unwanted pieces, though he was careful to retain forgeries which are now themselves widely collected and often hardly less valuable than the genuine objects they copy. Hunter himself, however, was probably fooled when he paid ten guineas for what was claimed to be a gold medallion of Alexander but which turned out to be a north Italian forgery of much later date.

He used a reputable London dealer, but generally his approach was similar to what he used to build his anatomical collections which had their beginning in his acquisition of James Douglas's anatomical material when the latter died. But by 1770 Hunter's net was wide, and some other coin collectors tended to regard his interest in their holdings as being predatory rather than benign and academic. For £900 he bought a large collection of Greek, Roman and medieval coins as well as a very large group of British and Papal medals from the son of Thomas Sadler who had originally built it up. His biggest buy, however, was the collection of Matthew Duane, a lawyer whose own collection was created over a lifetime of acquisition and included that of Robert Harley, the Earl of Oxford. Hunter bought this "on tick" for £8,000, to be paid in eight separate instalments which he met over the years 1776–9. It has been claimed that this process shows that Hunter funded the cost of his collections from his professional cash flow as an eminent medical consultant; but it may just as much represent his prudence since he seems to have had considerable amounts of capital even for such a large purchase. He was, however, by this time building several distinct collections in diverse fields.

Duane's was mainly a classical collection and Hunter augmented it the year before his death with the Hess collection from Vienna, bought for £2,400. Its main component, nearly 1,000 Roman Imperial gold coins, together with those already possessed by Hunter, established a magnificent run.

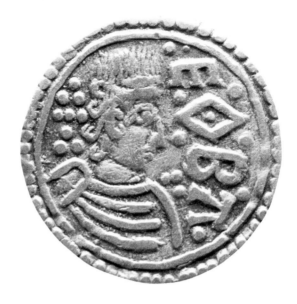

ENGLISH SILVER PENNY c. 790

Offa, King of Mercia 757–96, was a powerful king, acknowledged as the dominant ruler among the Anglo-Saxon kingships of his time. The remarkable earth barrier between the English and the Welsh on Mercia's eastern frontier, still visible to this day, bears his name. The interest in his coin, however, derives from its unique portrayal of a consort – the only coin in the history of the English coinage to do so.

A SCOTTISH GROAT OF JAMES III, 1484–88

A groat was a fourpenny piece but the fact that this would have been worth fourteen Scots pence illustrates the difference between the value of the two currencies.

A SCOTTISH DUCAT OF JAMES V

This splendid renaissance portrait of the King witnesses a swing back to the representational reality of royalty on coinage rather than something idealised and fictional. It is, for obvious reasons, often referred to as the Bonnet. The coins were first struck with the date 1539, but this is dated 1540. It is in better condition than the earlier example which is also in the collection.

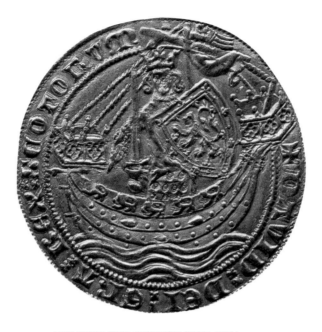

THE FIRST EVER SCOTTISH GOLD COIN

This lovely piece was bought by William Hunter for £21 and has always been rare. Only four are known to exist nowadays, possibly because so few would have been struck in 1357 in the reign of King David II. The king, who had been in captivity in England, was probably inspired by the example of Edward III's gold nobles.

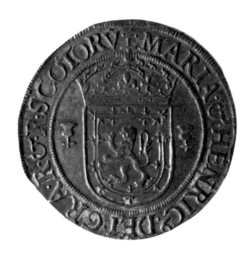

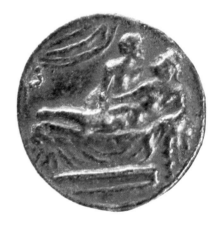

RYAL

This interesting ryal, or dollar, of Mary Queen of Scots bears the inscription "Mary and Henry, Queen and King of Scots". Notice how her name comes first as she was queen in her own right. Darnley was kept in his place. On equivalent coins, when Mary had been consort, her name followed that of Francis, which would have been the usual thing. The value of this coin would have been thirty Scots shillings.

SPINTRIA

This curiosity is one of a large holding of objects called spintriae which William Hunter amassed. Their precise role is not absolutely clear but they are thought to be brothel tokens from the fact that the reverse has a number stamped on it suggesting an individual or a room, for the numbers all differ. The other side is pictorial with images ranging from the erotic to the pornographic.

Of course he also bought individual coins, as can be seen from a perusal of his coin account book, for he was meticulous in his records if more as to cost than precise description. He seems to have paid £21 in 1780 for the gold noble of David II, the first gold coin to be struck in Scotland. He also then bought for five guineas a Saxon penny of Offa's wife, Queen Cynethryth, which is of great interest as the only example in English history of a monarch's consort being represented on the coinage.

His collection is weak on French coinage since he was competing there against the Royal collection (to which his own was often said to be second). Sometimes, however, he could use speed of decision to trump the superior purchasing power of the Bourbons. When Bruce, the discoverer of one of the sources of the Nile, arrived at Marseilles in 1774 with a superb group of coins of the Ptolemies of Egypt, the royal buyers haggled. Hunter stepped in and paid what Bruce asked.

The collection's medallions are significant. The Papal medals are especially interesting, not least because they all antedate Hunter's death, a point of import when many Papal medals went on being struck on request at much later dates from the original dies. Hunter's British medals and medallions also, by definition, antedate 1783, although purchase is trying to bring this section up to date.

Much of this material is obviously the stuff of treasure: Lord Boyd Orr's Nobel Peace Prize medal, for example, is a huge piece of solid gold of rugged rather than refined aspect. Academic notions of their worth are different from sale-room assessments, however. Coins are symbols of weight quite distinct from any fine metal content they may boast. One historian of Roman Britain has been able to hazard a guess at the political loyalties of Southern English tribal states on the eve of the Roman conquest depending on whether their coinage displayed wheat ears or vine leaves. The grain would suggest beer, the grape, wine; and contemporary political learnings might thereby be deduced. It is not too fanciful a construct given the way in which everything on a coin, after all a small area, has to be considered carefully by its makers.

Again, the prevalence of medieval English coins in Scotland has profound economic and cultural, if only small political, implications. Scholars will want to wrestle with these but those who view the coin collection simply out of normal human curiosity might easily forget that it leads to much more systematic and rigorous inquiry. In this respect the Hunterian holdings possess an unusual scholarly appeal because of their range in both time and space and because of their comprehensiveness within particular periods.

Joseph Black

IN THE NATURE of things few historical remnants of early chemical enquiry survive. The raw materials, so to speak, are not changed by any association with those who handled them. There are few surviving objects relevant to the beginnings of modern chemistry in Glasgow University where one of the most important figures of the Scottish Enlightenment, Joseph Black, was active. Inventories of materials and utensils in the chemical laboratory survive from 1769 and 1796 in the University archives, but tell surprisingly little; the same is true of early geological samples which date from Joseph Black's time. Other evidence suggests that even as great a figure as Black used very simple instruments and utensils, but the only instrument supposed to have been his which still exists is "Black's balance" which has been in the Royal Scottish Museum since 1858. It would certainly be hard to deduce from the brief inventories – each no more than a couple of folded sheets of paper – that Glasgow was the cradle of what has been called "The Chemical Revolution", a term which reflects better than "Industrial Revolution" the reality of the fundamental historical change that occurred during the middle of the eighteenth century.

Modern economic historians would be reluctant to confine either revolution to any brief time span but there is little doubt that great changes in thinking and mechanical processes did occur in the middle of the eighteenth century and Glasgow was the first home of some of the most significant. Many were associated with Joseph Black whose work on heat and on gases proved to be seminal.

William Cullen, so important to the early development of William Hunter, was probably the first man to establish chemistry as a science in its own right, independent of any supplemental role it might have had in metallurgy or pharmacy. Chemistry was in its infancy: it was necessary in 1751 for Cullen to plead (in a letter now in the archives) with the University authorities for £20 to allow him to continue the teaching of chemistry in which he had been appointed lecturer four years earlier. The first money had only been found by postponing the instalment of a professor of Oriental languages; the extra was found, however, and Cullen got his way. Among his pupils and laboratory assistants was Black, though he was then studying medicine, in which Cullen was also qualified.

Among Black's pupils may have been James Watt, as a private, not a

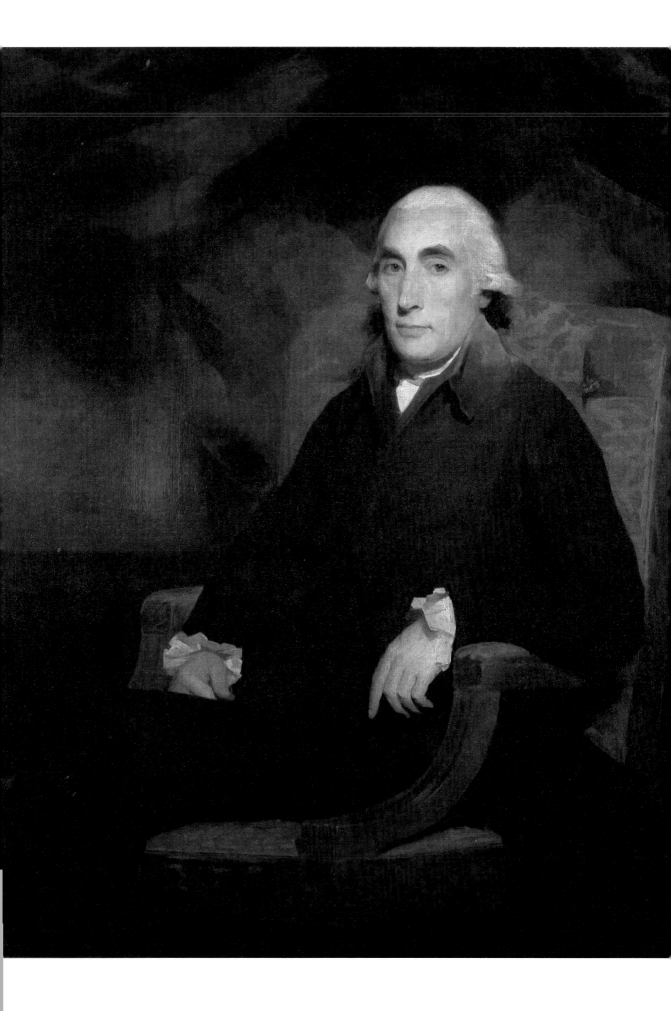

matriculated, student. Watt vigorously disputed this particular connection, and insisted that his steam condenser owed nothing to Black's discovery of latent heat. But he did help Black in his laboratory: it may even have been the more immediately practical Watt who directed Black's attention towards specific heat. Their relationship was certainly not merely academic. Both Cullen and Black had entrepreneurial interests – infant Scottish chemistry was closely attached to industry – and in Watt's case Black's capital was later to be vital.

Joseph Black is universally acknowledged as an immense influence, and his work figures in hundreds of books and learned papers. He left an autobiographical fragment, and there is a stimulating *Outline Biography* by R. G. W. Anderson which was published in 1982 in a symposium of papers by the Royal Scottish Museum to commemorate the 250th anniversary of Black's birth, in 1978. Some detailed preliminary work was done by A. L. Donovan and published in 1975 but Black still awaits a modern scholarly biography on the sort of scale provided for Lord Kelvin in 1989.

Born in 1728 in Bordeaux where his father was a wealthy wine merchant (and acquaintance of Montesquieu), Black was born of Scots and Ulster parentage. When twelve he was sent back to Belfast for his education; and this was continued in Glasgow when he was sixteen. It was when he was twenty that Black opted for medicine. This meant Edinburgh, whose medical school, though then very young, had quickly acquired a high reputation. In fact, the research work Black did on alkalis for his medical degree was of a straightforward chemical nature (though he added a medical dimension to his paper: alkaline preparations are well-known stomach settlers).

Several copies of that first paper were sent to Cullen and when the latter was appointed Professor of Medicine in Edinburgh in 1756 it was Black who replaced him to teach chemistry in Glasgow. It may be some indication of the tentative status of chemistry in that Black's title was Professor of Anatomy and Botany (in neither of which field did he feel competent) and that the following year he was made Professor of Medicine. It was clear, however, that chemistry was his main concern, though in a way reminiscent of William Hunter, being remarkably reluctant to publish his findings as formal papers. He did, however, read papers summarising his findings (on latent heat, for example) to popular intellectual bodies like the Glasgow Literary Society.

PROFESSOR JOSEPH BLACK
Sir Henry Raeburn (1756–1823)
Knighted by George IV on his famous visit to Edinburgh in 1822, Raeburn was the outstanding Scottish portrait painter of his time. Among his subjects were Scott, Hume, Boswell and Cockburn. He also painted many academic figures, among whose number was Joseph Black, looking here somewhat austere – more the entrepreneur than the research chemist. The University collections are comparatively rich in Raeburns.

He was even reluctant to produce details of his own designs, though others did so, as in the case of one of his portable furnaces which R. G. W. Anderson has discovered was still being advertised as late as 1912. It is true that his lectures were published in 1770, but it was without his knowledge let alone permission.

Black may have thought of himself as a teacher rather than a researcher. Perhaps he had to be: an eighteenth-century lecturer often had to draw a fee-paying audience because he may have had no university salary at all, which was the case when Black returned to Edinburgh as Professor of Chemistry in 1766. He certainly made his mark on listeners, one of whom was Henry Brougham who "enjoyed being present while the first philosopher of his age was the historian of his own discoveries, and [being] an eyewitness of those experiments by which he had formerly made them, once more performed by his own hands".

All of Black's important work was done at Glasgow. It was there that his findings on specific and latent heat were established; there that his partnership with James Watt was forged, Black backing his mechanical enterprises to the tune of £1,000. On his return to Edinburgh in 1766, Black's research output ended. He died in 1799.

Adam Smith

ANYONE WHO demands "human interest" in the study of great men will be disappointed in Adam Smith. Little is known of him personally, especially in his early years. Even the exact date of his birth is uncertain but it was around 1723, for he was baptised that year in Kirkcaldy where his father had been the local controller of customs. Smith père married twice; in the second case to Margaret Douglas of Strathendry, the daughter of a wealthy landowner. He died before the birth of his famous son who was never to marry, so no note of intimate family experience exists, saving a very few letters from Adam Smith to his mother. Some of his letters to Hume show an occasional light and witty touch but most reflect Smith's commonsense, a quality Smith himself found deficient in Samuel Johnson, who is elsewhere generally felt to have embodied the virtue. These two great ornaments of eighteenth-century British life did not "click", as Boswell was to record.

Few likenesses of Smith survive. There is an unattributed portrait in the Scottish National Museum in Edinburgh, the so-called Romanes portrait formerly owned by a Kirkcaldy family and widely reproduced in the last century by Annan in Glasgow. There is also an elegant statue in the Hunterian Museum, but it was executed well after Smith's death. A less flattering but probably more accurate image is conveyed by a Tassie medallion – it shows the austere-visaged profile of a large-nosed man in his sixties. There are bags under his eyes and the facial muscles droop. It is not a forbidding expression all the same.

Smith may have been a poor talker – his initial remarks were always hesitant, as if he needed to pick up speed before continuing fluently. He may even have stammered. But he was a sound lecturer, usually extempore, because of what he said rather than how he said it. One listener noted that "he never failed to interest his hearers".

If he was hardly glib in speech, he was more a fast writer. In a letter of 1788 to his publisher (in the University's possession) he confessed: "I am a slow, a very slow workman, who do and undo everything I write at least half a dozen of times before I can be tolerably pleased of it." Regrettably he was also "for the most part a perfunctory, dilatory correspondent" as the editor of his letters puts it.

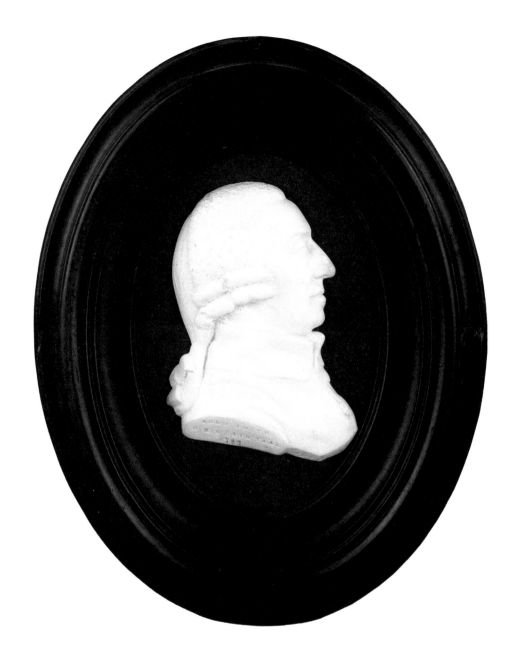

THE TASSIE MEDALLION

*For such a distinguished man, few certain portraits of Adam Smith survive. This medallion is his only sure image,
though the association of the Romanes portrait with Kirkcaldy is strong evidence for thinking it a genuine likeness
as well.*

*Apart from its subject, this medallion is of interest as being one of several round and oval portrait tablets made
by James Tassie (1753–99), the Pollokshaws-born stonemason and gem engraver, in the University's possession.
The Glasgow collection does not compare in size with the 150 medallions in the Scottish National Portrait Gallery,
and although it is not grouped as an entity, its items are choice.*

In later life he was to acquire a reputation for absent-mindedness which seems appropriate in one who was a distinguished professor in his time and has been widely regarded as a fount of instruction ever since. That sentiment is particularly marked at the time of writing when Adam Smith seems to enjoy a world-wide cult status for all that he only managed a single entry in the first two editions of the *Oxford Dictionary of Quotations.*

When four years of age, Smith was kidnapped by, and rescued from, gypsies, an event which, more or less, ends the dramatic in his life. Although he proved to be a very clubbable man (a great asset in eighteenth-century life) almost everything else of import concerning him is associated with his mental activity. This was certainly wide-ranging, covering every aspect of human behaviour, not just economic. He was fascinated by the origins of language and later students have found in some of his writings the beginnings of a theory of communication.

He began his University studies in Glasgow in 1737, graduated three years later and went on to Balliol for another six years by means of the Snell Exhibition. He seems to have been self-taught in his Oxford years which was just as well – Oxford was not then a hive of intellectual activity; it entirely lacked the mental sparkle which the Scottish Enlightenment conferred on Edinburgh and Glasgow. It inspired Smith, in a famous passage in *The Wealth of Nations*, to pronounce on the way lack of incentive in academic life promoted laziness: "In the University of Oxford, the greater part of the publick professors have for these many years given up altogether even the pretence of teaching." This, in his view, was because they enjoyed sinecures so that their income was entirely independent of their teaching, unlike the then Scottish system which related much professional income to the fees paid directly by the students.

At a later date, when Smith's *Theory of Moral Sentiments* was receiving a rapturous reception in London, one correspondent, whose letter of 1759 to the great man is now in the University Library, noted how "it comforts the English a good deal to hear that you were bred at Oxford, they claim some part of you on that account". It might well have done so, for Scots generally were not popular in mid-eighteenth-century London. James Boswell was really quite brave only a few years later to rise in a theatre and identify himself with two Highland officers whose conspicuous dress uniform ensured a vocal and nasty reception from hostile elements in the audience. But surely Smith was right in a letter to Hume a few years later to insist that London rather than Paris was the place to settle in spite of Hume's worries about such prejudice: "The hatred of Scotchmen can subsist, even at present, among nobody but the stupidest of the People, and is such a piece of nonsense that it must pall even among them in a twelve-month."

After giving some successful public lectures in Edinburgh, Smith became Professor of Logic in Glasgow in 1751. The following year he transferred to the chair

of Moral Philosophy, then a subject with a far wider net than now: it included natural theology, ethics, jurisprudence and political economy. Sadly for Glasgow, Smith's great friend, David Hume, failed to succeed him as Professor of Logic. Almost ten years previously Hume had similarly failed to secure a Chair at Edinburgh University. Given the quality of Hume's thought and published works, not to mention his subsequent reputation, these failures must now seem astonishing. They should certainly qualify any over-generous estimate of the good judgement possessed by the eighteenth-century Scottish academic élite: in both cases prejudice prevailed and Hume was condemned as atheistic.

Smith, who was eventually to be thought of as something of a successful academic politico in Glasgow University, seems to have had little influence in this affair. Perhaps he did not try too hard, assessing the extent of the animus against his friend as insuperable. Hume became instead Keeper of the Advocates Library in Edinburgh. His close friendship with Smith was to persist throughout his life and several letters from Smith to him are in the University Library.

Smith's reputation rests partly on *The Theory of Moral Sentiments* of 1759, but mainly on the great work, popularly known as *The Wealth of Nations*, its short title. That does not by any means exhaust his writings but *The Wealth of Nations* appeared comparatively late in his life in 1776 (he died in 1790) and certainly enshrines his most mature thoughts. It was designed as part of a trilogy of which *Moral Sentiments* was the first component. The third section in law and government was never to appear. Had it done so the full breadth of Smith's system building would have been obvious. As it was, Smith's lectures on jurisprudence – which would have been at the core of his final work – were not discovered until 1895. A second and fuller version was discovered in 1958 and first published twenty years later. Since these are lecture notes it would not be fair to assume that Smith's third intended work would have been confined to their material, but they are powerful indicators.

None of this latter material was known to Marx; and it is intriguing to wonder how far its availability might have altered that thinker's attitude to Smith. As it is the influence of *The Wealth of Nations* alone has been enormous and only Marx's own *Das Kapital* has exerted a comparable force, opposing its more romantic vision to Smith's apparent rationalism. Given the way in which the apocalyptic and determinist elements of Marxism have just received a profound blow from the systematic failure of attempts to apply versions in Eastern Europe

ONE OF ADAM SMITH'S SILVER SPOONS
Object as icon, this spoon derives its special interest from its association with Smith and its likely purchase, with others, from the proceeds of The Wealth of Nations *which sold extremely well for its time.*
It is a typical piece of eighteenth-century Scottish domestic silver, echoing in its simplicity and attractive austerity the qualities already established by earlier Scottish silversmiths and evident in other more important items in the University's hands.

it would hardly be unusual to find a marked sense of triumphalism among Smith's contemporary followers.

The modern interest in his thought is, however, far more broadly based and antedates the Gorbachev initiatives by some considerable time. In fact it must be true to insist that Smith has never fallen from regard but that the intellectual reaction to the Social Democracy prevalent in the West between the 1930s and 1950s has evoked a new wave of politically inspired interest. This wave has also been ridden with considerable enthusiasm in Japan and among the other developing economies of east and south-east Asia.

The reason is that Smith offers a model for economic development along liberal capitalist lines where the market reigns supreme in responding to and satisfying individual choice: Smith is the apostle of *laissez-faire* though not its dogmatic advocate. If even the Devil can quote Scriptures to his own benefit, it must be admitted that in the whole body of Smith's work there can be found sentiments which might suit somewhat different points of view. As one American academic put it: "Two centuries of examination under a magnifying glass have left few aspects of *The Wealth of Nations* exempt from meticulous study." (He then went on to identify and consider one lacuna!)

It is not now considered a university's job to endorse or propagate any one point of view (how things have changed since 1451!) but to disseminate as widely as possible all findings and opinions so as to encourage their critical examination. This would have appealed to Adam Smith who approached most problems with a refreshing scepticism.

In that spirit Glasgow University planned and published in new scholarly editions all of Smith's works and known surviving letters to mark the bicentenary of the original publication of *The Wealth of Nations* in 1776. In tandem it also published a collection of thirty essays by modern scholars examining and assessing varied aspects of his works and their remarkable influence.

It should not be too much to say that Adam Smith is Glasgow University's most influential graduate. The connection has of late stimulated a steady flow, particularly from East Asia, of what almost seem like pilgrims anxious to see what contemporary relics remain of him. Apart from the Tassie medallion, these are all documentary. Even so, what survives is far less than it might have been since, just before his death, Smith gave instructions to his executors to burn his personal papers. The Special Collections of the University Library nevertheless contain 240 documents relating to Smith's life and work. They are known as the Bannerman papers for they came into Glasgow's possession from the gift of the Revd Dr David Douglas Bannerman, who was a descendant of David Douglas, Lord Reston, Smith's heir. Their original number has been increased over time both by other gifts and outright purchase, a process which continues as items become available, mostly through auction.

Lord Kelvin

FROM A COIGN of the Kelvingrove Park facing the river from whose name he took his title, William Thomson, Lord Kelvin, looks out for ever with sightless eyes. Only a hundred or so yards away, trays in the University's coin cabinet hold, resplendent, large numbers of honours and decorations; his accumulated tribute from governments and academic institutions round the world. He was said to have more letters after his name than any other man in the country.

Monumentally respected and much decorated, Thomson seemed to many contemporaries to possess the nineteenth century's finest scientific mind. The relentless growth in awareness of the significance of Darwin's work is bound to have altered that estimate but, much as an increasing regard for Mozart's music has left Beethoven's status unaffected, nothing has happened in Darwin's rise to diminish Thomson's reputation.

William Thomson was something of a child prodigy. Born in Ulster (near Belfast) in 1824, he was the fourth of the seven children of James Thomson who came of a Scots family which had moved to Ireland in the seventeenth century but always retained its direct Scottish links. James Thomson was himself educated at Glasgow but returned to Belfast where he taught mathematics for eighteen years and eventually made a good living by publishing a series of remarkably successful mathematical text books. He became Professor of Mathematics at Glasgow in 1832.

William's mother died when he was six, and this, together with the way in which Thomson personally tutored the boy, may help to explain the particularly close relationship which grew up between father and son. William entered Glasgow University when he was ten years of age, was a gold medallist at fifteen, and studying further at Cambridge University when seventeen. He graduated from Cambridge in 1845 at the age of twenty-one, many of his examiners finding the quality of his work superior to their own.

He could have had an academic career at Cambridge (and its powers sought to entice him back there several times in later years) but Glasgow beckoned more persuasively. James Thomson worked hard to ensure that William – who anyhow tended to do what James told him – would become Professor of Natural Philosophy in Glasgow, and the chair fell vacant in 1846. James Thomson deployed

63

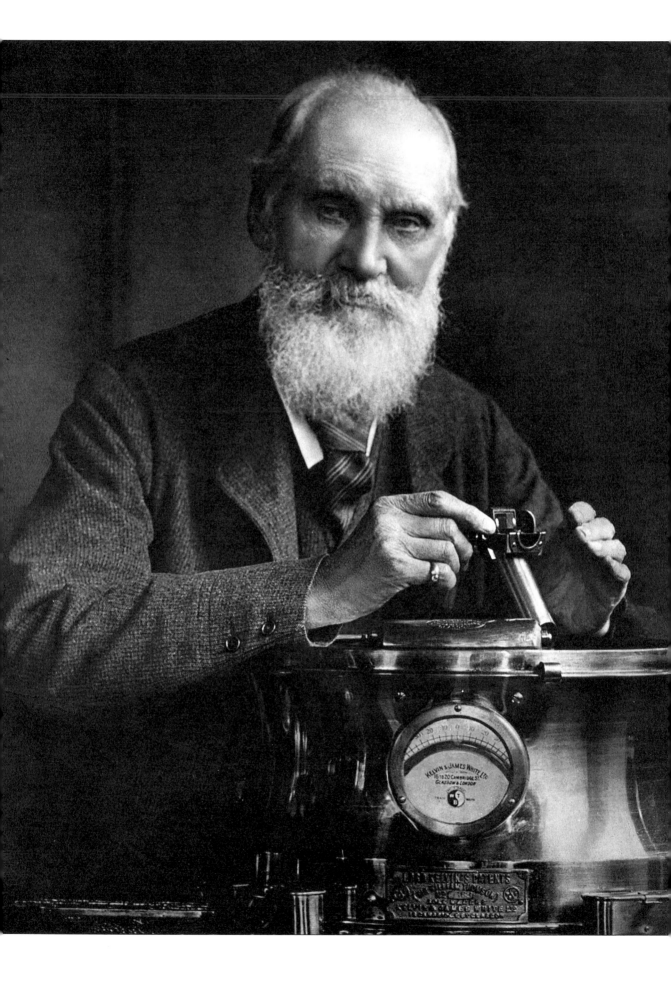

both assiduity and political skill to ensure that William got it. Seldom can nepotism have been more justified and benign. William Thomson was never to leave the University. Instead he used it as a base from which to revolutionise the teaching of academic physics, to extend massively its range in respect of his own discoveries, and to tie it closely to the practical world of industry and commerce. His mind was such that he could always visualise the abstract in concrete or mechanical terms. In some ways this may cut him off from other modes of thinking, which helps to explain why others, like Maxwell, could sometimes jump ahead of him. It did, however, ensure that he was always at home in the wider world outside academia and saw no necessary dichotomy between the two. Long before "the enterprise culture" was coined as a phrase, Thomson may be said to have embodied it, patenting his inventions and selling his services as an industrial consultant.

It should hardly surprise readers that the Glasgow Senate which appointed him had some initial doubts. That Thomson had practical skills as well as theoretical knowledge was attested by his having studied, no matter how briefly, in the Paris laboratory of the distinguished French physicist Victor Regnault but his new employers had to be reassured that he could also communicate easily with students (then normally much younger than they would be now). They need hardly have worried. William turned out to be a sound lecturer, often without the benefit of a written text, though in his later years undergraduates apparently preferred his junior colleagues.

Among his accomplishments was the establishment of the practical laboratory for the teaching of physics which became the model for universities everywhere. It was always a research laboratory as well as a teaching one, for in Thomson's mind these two functions were best kept in partnership. His students were unpaid volunteer aides to his own work – but he was always scrupulous and generous in listing their names to any papers published from their collective effort.

This laboratory started in a basement in the Old College but had soon expanded into the room next door even though it contained the famous Blackstone Chair on which previous generations of students had sat to be examined *viva voce*.

LORD KELVIN AND HIS MARINER'S COMPASS

The firm of Kelvin and White manufactured more than 10,000 of these compasses for use in ships the world over. The advent of iron ships had resulted in substantial errors in compass readings which had to be corrected by elaborate means. Great care was needed with the design of the compass if such corrections were to be successful and sailors not lured to disaster. The theory of magnetism in iron ships was worked out by Archibald Smith, a fellow student of Kelvin's and brother of his first love, Miss Sabina Smith of Jordanhill. The picture shows Kelvin posing with a compass carefully arranged for maximum commercial effect.

As a performer Thomson was probably less imposing than William Hunter but he taught with even more gusto. For all that he had had a submissive boyhood, he loved the dramatic gesture, and revelled in demonstration which exposed the practical reality behind theoretical points. For example, he played the French horn to his classes (with what degree of technical excellence is not known) to illustrate aspects of the nature of sound. Another demonstration involved his firing an elephant gun, and this achieved sufficient fame for it to be re-enacted by a successor in 1951 at one of the lectures delivered to mark the celebration of the University's first 500 years. With an economy which Thomson would have admired, the celebrant insisted that he give his public lecture simultaneously with a class lecture, thus "killing two birds with one stone". The venue was the splendid lecture theatre finished in 1907, the year William Thomson died, but conceived as he would have liked it with steeply rising tiers of seats (lifting the topmost row about twenty-five feet above the teacher) and a high gantry for all the paraphenalia which had by then come to be associated with the teaching of physics.

The lecturer was performing well and at the appropriate moment let off a gun, though of much more modest bore than an elephant gun, to make anew Thomson's point. To his consternation, a blood-spattered pigeon fluttered down from the gantry. Of stern stuff, he had just collected himself sufficiently to mutter that he had said "two birds with one stone" when a second blood-spattered pigeon fluttered downwards to much laughter. He was the victim of a memorable practical joke.

Thomson's own demonstrations sometimes went more seriously astray, as when he once hit a spinning gyroscope with a hammer. This was intended to show the instrument's stability to a distinguished visitor. Instead the gyroscope flew off its mounting slicing away the man's hat: it might as easily have sliced his head. That incident explains why, although Thomson lectured with considerable verve, the actual demonstrations were usually performed at his behest by assistants. Folklore, of which quite a lot still attaches to his memory, insists that the assistants were often reluctant to let him use the equipment they normally had made themselves, though to his design. For all his genius, Thomson was apparently ham-fisted. He could conceive and describe to others – often in a flash – the most revolutionary constructions, but he could seldom make them himself, and he tended to use them with a disregard for their delicacy, even

CABLE GALVANOMETER

Kelvin invented a number of exquisitely sensitive electrical measuring devices. Galvanometers detect the passage of electricity, and the cable galvanometer was designed to detect the very tiny signals transmitted along submarine cables, whence its name. It was the use of this device, coupled with Kelvin's unique understanding of the physics of electrical propagation in cables, that led to the successful completion of the Trans-Atlantic Cable Project in 1866.

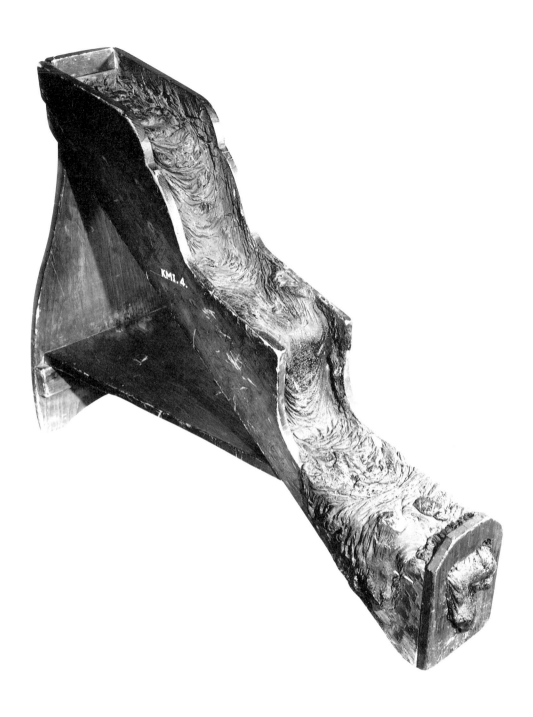

PITCH GLACIER

The world's second-longest-running demonstration experiment. Kelvin was deeply perplexed by the propagation of electricity and magnetism through apparently empty space. He supposed that there must be some medium filling space which was not ordinarily apparent to us. Such a medium would need to respond very differently to fast and slow movements, and Kelvin noted that pitch behaved in an analogous way. If you hit a block of pitch with a hammer it shatters like glass, but if you leave it to itself it will flow very slowly like a liquid. The pitch glacier was set up in 1887 and has been slowly flowing ever since.

though they were sometimes made for the most sensitive measurements – of feeble electrical signals, for example. We know that he was unable even to trust himself accurately to bore holes in wood for he kept a meticulous record of the spending of his department, and charges for items of that nature figure in the pages of the notebook of departmental spending he felt compelled to keep.

These accounts are still in the possession of the Department of Physics. It may have been a natural thing for Thomson to have done for he had a commitment to precise record-keeping even to the point of signing and dating, to the hour as well as the day, the annotations made in books he read. (This quirk has enabled one researcher to establish that Thomson read a work of another physicist,

THE PURGATORY BOX

A feature of Kelvin's teaching was the daily oral examination in which students were called upon to stand and answer a question. For this purpose Kelvin kept the box shown in the photograph. Its three compartments contained slips of paper bearing the names of students who had yet to be called (Purgatory), those who had answered satisfactorily (Heaven), and those who had not (Hell). If too many students ended up in Hell it was a sign to Kelvin that there was a difficulty and the subject matter was taken up and explained again.

THE HARMONIC ANALYSER

The machine shown in the photograph is a special purpose analogue computer built by Kelvin using a mechanism that had been invented by his brother James, who was Professor of Engineering in Glasgow. Its purpose was to separate the various wave-like components contributing to the rise and fall of the tide and allow the prediction of future water levels. It is one in a series of machines that Kelvin designed to solve the very complicated and commercially important problem of tidal prediction in sea ports.

Maxwell, with whom he disagreed, on at least five separate occasions.) But probably this record sprang from another early doubt of his superiors. He always knew the value of laboratory materials and equipment but his early requests for money to buy them awakened immediate fears that he might prove spendthrift. He had to report to a committee on how his modest agreed budget was disbursed. That this committee continued to meet for well over twenty years may be an interesting example of bureaucratic inertia: long before then Thomson's prudent care of other people's money had been well established.

Nearly all the equipment bought or made to his design still exists and, along with the elephant gun and French horn, is preserved in glass cases in a small museum housed in the tea-room at the Department of Physics. It looks completely innocent of excitement to the untutored eye. The instruments Thomson made for measuring current along the Trans-Atlantic cable seem slight as well as, somehow, very ordinary. But physicists have a quite different vision of them. This museum attracts a steady trickle of visitors from all over the world. Those who can appreciate the significance of the collection "flip when they see it", says one of Thomson's successors in today's Physics Department. With other items in other locations in the department it is probably the largest and most comprehensive collection of early scientific equipment in the world.

The University also retains two of his long-running experiments, one of which will take another 120 years or so to complete and has for that reason attained considerable fame from its entry in the *Guinness Book of Records*.

Thomson's work was mainly in the fields of heat and electricity where he greatly extended the range of knowledge and, in the view of his latest biographers, "transformed classical physics". Its influence, which among other things supplied much of the underpinning of subsequent relativity theory, remains massive. He seized the public imagination chiefly, however, with his

LORD KELVIN
William Rothenstein (1872–1945)
Rothenstein produced several studies of Kelvin in old age. This fine pastel of 1904 was presented to the University
in 1924 by William Rothenstein and Professor A. A. Jack. It displays the artist's skills well – he was especially
adept in chalk and pastel.
Rothenstein was by no means in awe of his subject: while recognising that Kelvin was "a scientific Titan", he added,
"but a duller man I have never met."

work in connection with the Trans-Atlantic telegraph cable, and the success of this project of enormous magnitude owed much to his energy and intellectual grasp. He was involved directly in the cable-laying activities and invented the telegraph receiver, and later improved it, for use on the cable. This work led to his knighthood in 1862 but that honour in no way impeded his fertility. He developed an important mariner's compass used by the Admiralty, instruments for measuring the rise and fall of tides and sounding equipment.

All of these activities combined to make him unusually rich and in a memorable way he combined the Victorian virtues of intelligence, personal application and industrial success.

There are limits to even the finest of human minds. Thomson was not always right: he thought, for example, that no heavier-than-air machines would ever fly and that the aerial future would be dominated by balloons. He did not respond favourably to Darwin's great theory, partly because he miscalculated the age of the Earth, but partly also because of the way in which evolutionary theory assaulted his religious convictions. But these points – and others more narrowly focused in contemporary research findings which he might have anticipated – are bound to have a carping quality: genius cannot be defined by what it does not achieve but what it does. The biography of Thomson by Crosbie Smith and Norton Wise, published in 1989, is a sustained and triumphant demonstration of that genius.

Not all of his students were Scots. There was a significant Japanese connection with Glasgow in the late-nineteenth century. Just as the Japanese armed forces sought to model themselves on the best European exemplars (the Imperial Army took the Prussian Army and the Imperial Navy, the Royal Navy) their civilian interests sought the academic best. The usual thing was for such students to have one or two years of study rather than a full course culminating in a degree. Whereas chemists trained in German universities, physicists and engineers came to Britain. In the light of Thomson's standing and the Clyde's shipbuilding, very many of the latter groups came to Glasgow, a connection recently illuminated by the studies of Mrs Olive Checkland.

Thomson was made Lord Kelvin in 1892. There probably was no academic honour he did not receive in his lifetime. It remains an astonishing thought that he held the Chair of Natural Philosophy for more than half a century and became the Chancellor of the University which he had first entered at such a tender age. He is buried in Westminster Abbey but his huge surviving correspondence is safely kept in the two universities, Cambridge and Glasgow, which gave him the opportunities he so securely grasped. These letters certainly expose the clarity of his mind but they also disclose the more human and occasionally intense emotional side of a personality which is always in danger of being overwhelmed by the weight of its scientific output.

The Hill Adamson Photographs

EXPRESSIONS OF firm opinion are the historian's delight – even when wide of the mark. Ruskin's splendid dismissal of the artistic potential of photography springs to mind. Photographs were, he thought, "for art purposes worth a good deal less than zero". Such confidence, similar to that which affected his judgement of Whistler, may elicit feelings of delicious smugness now, but Ruskin was, in both cases, with the majority. It was a long-persisting one and helps to explain why so much early photographic material of value has been lost.

Ironically, it was his own artistic inadequacy, his "faithless pencil", which first led Henry Fox Talbot, its main creator, to photography. And it was the demands of art which took David Octavius Hill into his remarkable photographic partnership with Robert Adamson. Hill, a founder of the Royal Scottish Academy and for forty years its secretary, was the painter encouraged by Lord Cockburn to commemorate the foundation of the Free Church of Scotland in 1843. He was to produce a huge work depicting all the seceding ministers. To facilitate this, and ensure that he really caught the likenesses, Hill felt he needed some hundreds of individual portraits. He enlisted the aid of Adamson, an Edinburgh chemist who had been exploiting Fox Talbot's calotype process for portrait-making. Together, inside six months, they had a considerable number of portraits and went on to produce many photographs of other subjects, until Adamson's early death in 1848 terminated the partnership abruptly.

Although often called a "great picture" Hill's painting deserves that accolade only because it is an historical document; it is otherwise as dull as a college or school photograph which it resembles in its numbers, and the long rows of its composition. One could not tell from this painting that the Disruption might be seen as the central experience of nineteenth-century Scotland, liberating immense forces of energy, collective as well as individual, material as well as spiritual. (And arguably dissipating these same resources in a civil war of words and the unnecessary duplication of church buildings.)

Artistic representation of historic events is, however, always difficult – as the very different efforts of David and Lavery will show – but possibly the democratic nature of the Free Church worked to Hill's despite since it denied him the focus of a dominant personality or hierarchical setting. The calotype portraits are a

very different matter: the power of personality is caught in many of its subjects including, perhaps especially, Thomas Chalmers, the dominating force of the whole movement.

Lord Cockburn was enthused enough to insist in the year before Adamson's death that Edinburgh had become "the paradise of calotype". The Hill Adamson portraits have certainly come to enjoy deserved international recognition as works of art of the highest quality; a status shared by the smaller number of group scenes, of Newhaven fisherfolk, for example; and the even fewer pieces with unusual items of interest, like Mons Meg at Edinburgh Castle or views of St Andrews. (These last, in *St Andrews from the Beach*, were the partners' sole attempt to publish their work. It is as attractive as it is rare, even though for chemical reasons the calotype process was not at its best in landscape for it could not easily cope with greens.)

There is some academic dispute as to which of the partners deserves the main credit for the success of their work. Possibly Adamson's crucial role, which certainly seems to have ensured the technical excellence of the production, was underrated earlier. An artist's sensibility is, however, everywhere evident in the compositions, and Hill possessed that quality as well as having training and experience. It is something of a sterile argument, because incapable of resolution, but one given an intriguing zest by the way in which Adamson's death brought everything to such a close in 1848, although Hill was to live on for another twenty-two years.

In 1953 Glasgow University acquired by purchase a large collection of early photographic material, mainly Hill Adamson works. The seller, R. O. Dougan, was about to leave Perth to become Deputy Librarian of Trinity College, Dublin, and later Librarian of the Huntingdon Library in California. Mr Dougan did not dispose of all his collections to Glasgow – others are now in New York and at Princeton University – but with existing holdings what came then made the University an important centre for the study of early photography.

Dougan acquired the Hill Adamson material from the artist's house on Edinburgh's Calton Hill where it had remained from Hill's death in 1870. There are 493 paper negatives, 324 glass negatives, 411 original calotypes and 459 later prints. If, as is thought, the partners produced only about 1,500 photographs altogether, this is a goodly slice of their output, surpassed in extent only by the collection in the Scottish National Portrait Gallery. Moreover, the quality of the Dougan material is very good. It is now well housed in conditions which protect it from exposure to intense light or damaging changes in temperature and humidity, while still leaving it open to easy scholarly access.

The University already had some Fox Talbot items and, dealing with Glasgow itself, and the University itself in particular, much of the work of Thomas Annan. Annan was Glasgow's first photographer of note but, much like Mackintosh,

THOMAS CHALMERS WITH HIS GRANDSON

Chalmers was the most important figure in the Disruption of 1843, the event which indirectly caused the Hill Adamson partnership to be formed. The University's Hill Adamson collection has several portraits of Chalmers. This one is not important because of its subject, however, but because it appears to have ushered in the later Victorian vogue for such combinations of youth and age.

DAVID WELSH

The Moderator of the Church of Scotland in 1843 and a prominent Edinburgh academic divine, Welsh led the secession of 150 ministers from the Assembly of the Church in that year. This striking portrait is one of the number which Hill caused to be taken for his painting of the event.

NEWHAVEN LADIES: *SALT PRINT*

Hill and Adamson intended to produce a series of six volumes of calotypes, and one of these was to be called The Fishermen and Women of the Firth of Forth. *It never appeared, but a number of particularly fine photographs were taken of Newhaven fisher-folk between 1844 and 1845, and these have retained their appeal ever since. Hill posed them, and to that extent they are not entirely natural. The Newhaven fishing community was also probably untypical in its dress – something of the remarkable effect of these pictures derives from this – and they are more romantic than real in the sense that no direct social, or economic, comment is implied by them: there is no hint of the hardship or poverty associated with such a livelihood, but the beauty of the images is uncontestable.*

MONS MEG

The huge gun, made at Mons in 1449, is one of the finest surviving pieces of medieval artillery and a great tourist attraction in Edinburgh Castle. It was originally made to the order of Philip the Good, Duke of Burgundy, and was presented by him in 1457 as a gift to James II who had married his niece. The modern salt print of the Hill Adamson calotype shows how that technique conferred great atmospheric effect and subtlety. It also had drawbacks, and any imperfections in this image derive from the original. Hill and Adamson went in for retouching to correct what they felt to be imperfections.

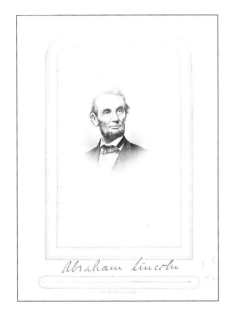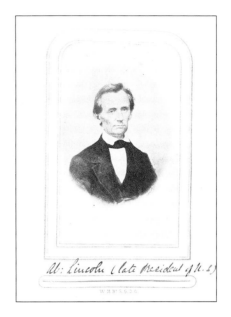

Abraham Lincoln

Al: Lincoln (late President of U.S.)

TWO SNAPS OF LINCOLN

No great historical, or photographic, significance is implied by these snapshots, though they do show the ravages the Civil War imposed on Lincoln. Victorians collected such "Snaps" of the high and mighty and inserted them in albums of which the Dougan Collection has several. Their value to historians is greater in the case of some of the less-well-known subjects, of whom few visual images have elsewhere survived.

insufficiently respected at home until, a decade or so ago soaring sale-room prices alerted local attention to the quality of his pictures.

The Dougan material reinforced such existing holdings. It contributed odd items from works by Julia Margaret Cameron to rare early photographs of India just after the Mutiny, by Linneaus Tripe (which Dougan picked up from a museum which discarded them). It also includes several albums of mass-produced portraits ("snap size") of distinguished contemporaries which Victorians evidently found collectable, though they seem to have been fairly expensive since some are marked "6d", sixpence, on the back. These are more interesting than significant but still merit some attention: thus a gaunt Lincoln, in the well-known image of his Civil War stress, achieves an added poignancy from its juxtaposition with an earlier print of him as a young and coming politician.

THE EXHIBITION HALL

The Exhibition Hall of the Zoological Museum as reconstructed in April 1990 after a fire two years earlier. The building was originally constructed to provide a large central space for exhibits. This hall was lit by means of a glass roof whose panels were screened by manually operated blinds. Unfortunately that system was not sufficient to prevent damage. It has now been changed so that all present exhibits are completely protected from any direct exposure to light.

The Zoological
Collections

IT SHOULD by now occasion no surprise that Glasgow University's zoological collections began with William Hunter. There seems to have been no field which failed to excite his curiosity: he even bought an Egyptian mummy at one stage. It is hardly an exaggeration to say that he lived in a museum, for his house at Great Windmill Street was designed deliberately to contain, as well as living apartments, an anatomy theatre and "one magnificent room fitted up with great elegance and propriety as a museum". The elegance can still be guessed at from the handsome wooden cabinets he had specially made to house his coin and insect collections, for this furniture came to Glasgow in 1807 and still fulfils its original functions in the coin room and the zoological museum.

A new museum was built in Glasgow to house Hunter's material but, as Helen Brock points out, "no inventory was made of the collections on their arrival". Laskey's book *A General Account of the Hunterian Museum* which was published in 1813 does not fill the gap. It is not a systematic catalogue (and Dr Brock notes that he had a reputation for dishonesty). This failure continued with much of the zoological material, though partial catalogues were started. That need hardly excite wonder either when it is noted that the zoological museum today holds about one and a half million separate specimens. It is abundantly rich in insect life.

The zoological collections have been housed in the Department of Zoology since 1923. This is a highly successful building which was designed to have a museum which protected the exhibits from exposure to direct light though it still admitted too much overhead light. The original exhibition room, of splendid size, has been somewhat reduced by subsequent encroachments to provide additional laboratories. What remains is still a very large space holding a brightly lit and well displayed exhibition of material which has the dual function of meeting undergraduate requirements as well as those of a more general public to whom the museum is open. The undergraduate level at which the material is aimed is the second year, a point in student life which will suit also non-specialist visitors.

Hunter's surgical work often led him to insights which, since the triumph of Darwinism, may seem commonplace but which when their own time is

THE GABON BEETLE

This splendid fellow, the largest animal in the tray illustrated previously, is a Goliathus goliatus. It was found floating in the Gabon River in western Central Africa (hence its popular name "the Gabon beetle") and presented to William Hunter in 1766. A type specimen, it was kept, and remains, in remarkably good condition. It serves to show how Hunter's reputation as a collector of animal exotica attracted all sorts of valuable items in addition to his own purchases.

A TRAY OF BEETLES

Huxley thought that God must have had an inordinate fondness for beetles, having created so many of them. They are certainly well represented in William Hunter's collection from which this tray is taken.

A LEG OF AN AEPYORNIS OR ELEPHANT BIRD (PLASTER CAST)
Such giant flightless birds existed in Madagascar possibly as late as
the thirteenth century AD. The New Zealand Moa was somewhat
similar, but only half the weight. Massive legs were obviously required.
An egg of the Aepyornis, the largest bird's egg known, would hold
the contents of 180 chicken eggs. Fragments of the eggs can still be
found in Madagascar and may have encouraged speculation about
the creature which laid them, so fuelling the legend of the Roc (Rukh).
It was this bird which carried Sinbad off to the wonder of readers
of The Thousand and One Nights *and delight of Hollywood film*
makers. The creature was also believed to have been capable of
carrying off elephants, hence its name.

remembered must seem especially remarkable. Thus studies of cardiac malformation led him to believe that "the most perfect and sound animals upon the whole, will have the best chance of living to procreate others of his kind, in other words the best breed will prevail . . . and that which is defective . . . will be cut off ". That opinion was written nearly eighty years before Darwin published *The Origins of Species* and almost fifty before his voyage in the *Beagle*.

Hunter was interested in all living things and sought to collect examples of anything rare and exotic. Where possible he tended to buy his zoological collections ready made by others; and it is clear that he was not a consistent and systematic observer of living creatures as Darwin trained himself to be. He was often the recipient of gifts. Queen Charlotte, for example, presented him with the dead bodies of a zebra and an elephant for his London museum. These bodies have disappeared but the massive tusks of the elephant remain.

Other material has been more fortunate. He acquired many interesting specimens of coral brought back by Cook from the South Seas and these contain about twenty examples of type specimens, that is, the first specimens ever collected of new creatures – new, that is, to Mankind. The uninitiated may gape at the enormous elephant tusks but scientists will prefer the type specimens of which there are also large numbers in the insect collections.

Hunter built up a fine collection of shells. This was probably second in quality to the famous collection possessed by the second Duchess of Portland. It is sometimes said that he bought part of her collection which was auctioned with others of her possessions after her death. Since he predeceased her that is not possible. (John Hunter, who also collected material brought back by Cook, might have been a purchaser at the Portland sale in 1786.) William did buy, in one bloc for £1,100, the large shell collection built up by John Fothergill, a Quaker doctor who died in 1780. Fothergill's collection included the shells which Sydney Parkinson, the natural history artist accompanying Cook, had collected on that sailor's first trip to the South Seas. For all that, one student of the subsequent dispersal of the zoological specimens from Captain Cook's voyages (P. J. P. Whitehead) cannot attribute to these voyages a definite provenance of many of the surviving Hunterian specimens. More recent research has, however, identified some specimens. There is scope for some more detective work here. Indeed there is much in the Hunterian material – and other collections later acquired by the Department of Zoology – which invites assessment and cataloguing. The insect collections especially offer scope for study, their hundreds of thousands of specimens neatly pinned along with descriptions of their original locations, collector and date of capture. They include the remarkable collection amassed between the 1890s and the 1920s by J. J. F. X. King, then librarian of the Glasgow School of Art, who was also an enthusiastic amateur entomologist with professional standards and a record of scientific publication.

A THYLACINE WOLF

This strange animal, looking very much like a dog, is in fact a rare Australasian marsupial. Fossil remains disclose a distribution all over Australia and New Guinea. In historic times knowledge of the animal was confined to Tasmania where the last known example survived three years to die in Hobart Zoo in 1936. Its elimination in mainland Australia might have derived from competition with the dingo but its fate in Tasmania was the outcome of its supposed preying on sheep and the consequent bounty imposed upon it by the Tasmanian government. This example came to Glasgow from the Andersonian Museum; frustratingly nothing else is known of its personal history.

MONKEYS

One of several charming drawings by Alexander Haddow, a product of the Department of Zoology and eventually Professor of Tropical Medicine and Dean of the Faculty of Medicine. Haddow began as an entomologist and epidemiologist in East Africa. He studied the transfer of viral diseases in tropical environments, established the transmission of yellow fever virus, and made many pioneering discoveries on the role of insects, monkeys and other animals in the spread of disease. This work led to his being elected a fellow of the Royal Society.

His interests were wider than the purely medical: he was the first to study the ecology and behaviour of forest monkeys in Africa. This accompaniment to a paper on Cercopithecus monkeys displays another of his many gifts.

These collections have had little systematic academic scrutiny for more than half a century. They remain ready in stacks of trays which emit faint whiffs of moth balls when opened, a reminder that the contents themselves have to be protected from the possible attention of today's insect life.

There is a large bird collection (though nowhere as numerous as the insects) and as well as British species there are large numbers of Himalayan and south-east Asian birds originally collected on the spot in the later years of the last century.

There are several small but valuable unusual collections, of antelope, elk and deer skulls, for example. Many of the latter derive from the hunting exploits of the Victorians and are mounted as trophy heads. Their modern interest is not decorative, however. For example, one of these objects is by far the best preserved specimen of the rare blue buck in the world, a species now extinct. Not the least of the scientific value of all this museum's holdings is that they include a fair range of life forms which, sadly, are now extinct.

Today's zoologists have no illusions about the supremacy of Man in the history of evolution but the material displayed in the museum mainly concentrates on the animal kingdom and within it the vertebrates. That is because this approach is the easiest way into the scientific study of the subject and certainly the way to attract the widest non-specialist interest. There is plenty to ooh! and ah! at; plenty of exhibits to evoke "Did you know that . . . ?" There is a large tank of living tropical marine life; a live boa as well as a (very large) stuffed python. There is the (plaster cast) leg of an elephant bird, long extinct and bigger than most men. There are remnants of dinosaurs, skeletons of false killer whales. And so on, in what could easily become an exotic catalogue. All the sort of things which every museum deploys to display its underlying function to a wider world. The real function of any University department is academic, and so its life will always be more mundane than exotic but an awareness of the wonderful is the first lure to study. The zoological museum is alluring.

BUTTERFLIES

There is no evidence that William Hunter ever netted a butterfly in his life, but he built up a considerable collection by purchase so that the University now has a few thousand specimens from all round the world. These are lovely examples. The blue, Morpho menelaus, is widely distributed in South American rain forests. Its brilliant metallic colour is remarkable. The red, Callicore pithias, is also South American. It has frightening eye spots on its underside, designed to deter would-be predators. Both might be under threat if the destruction of the tropical rainforest maintains its present relentless pace.

89

THE ABDICATION OF MARY QUEEN OF SCOTS

Gavin Hamilton (1723–98)

*Gavin Hamilton was the most distinguished painter also to have been a student of the University which now holds
several of his important works. Something of an antiquarian and successful dealer in Old Masters, he lived most
of his life in Rome. He did extremely well financially from history painting, a genre in which he became pre-eminent
and a major influence on subsequent European practitioners, notably David.*

The Paintings

NEARLY TWENTY years ago Glasgow University mounted a London exhibition of its pictures (at Colnaghi's). It excited much critical acclaim. And well it might with its particular riches in respect of Whistler and Mackintosh and its wide range of examples of European painting and print-making from Old Masters until modern times. Now that nineteenth- and twentieth-century Scottish painting is achieving both enthusiastic critical scrutiny and very high sale-room prices, it is gratifying to record that the Hunterian Gallery also boasts a very fine native collection even if, like General Booth in Lindsay's poem, we might all "groan for more".

Almost inevitably, the present collection begins with William Hunter. How his own taste was formed is not absolutely certain though Andrew McLaren Young thought he was bound to have been influenced by the attempts of the Foulis Brothers in 1753 to establish an academy in Glasgow for the training of artists – painters, sculptors and engravers. The brothers may have been ahead of their time – they were certainly ahead of the Royal Academy, founded in 1768. Sadly, their collection was almost certainly mainly bogus. When sold at Christies in 1776 it fetched a derisory sum given that it had over 300 items. Nevertheless it contained what were claimed to be examples of the work of Raphael, Titian, Rubens and Rembrandt (all in some profusion) as well as a long list of less numerous works by such distinguished names as Leonardo, Michelangelo, Poussin, Van Dyck and Breughel. There seems little point in speculating about the exact quality of the works involved but that they were forged and fraudulent may not have detracted too much from their influence. A time which has just endured the pain of having so many Rembrandt's "declassified" so to speak, is better placed to take this point than most.

William Hunter became Professor of Anatomy to the Royal Acadamy in 1768 so that he was involved in the contemporary art world. He was by that time rich and kenspeckle in London society and it should occasion no surprise that he was a patron of artists as well as a collector. Sometime in the 1750s, he commissioned Allan Ramsay to execute the first of four known portraits of him (the last by Reynolds was painted after Hunter's death). It is in the University's possession,

as are the three works by Stubbs, commissioned to illustrate unusual animals in which Hunter was interested as a student of comparative anatomy.

The Ramsay portrait can be explained, as such portraits were and remain, as an index of self-esteem; but Hunter used one at least of the Stubbs's works as a visual aid to a lecture. It was in this respect the equivalent of an anatomical specimen, its accuracy attested to by his assertion that it had been "done under my eyes". What we see as delightful, even charming, paintings had a more academic origin, though Hunter probably had the aesthetic enjoyment of them too. They are not the only Stubbs works held by the University for the print collection has an example of a graphic view of a horse (the painter's favourite creatures) engaged by savage lions.

That Hunter did have a good eye, and independent judgement, receives confirmation from his buying three fine Chardins, a contemporary French genre painter, long before his reputation reached anything like the modern estimate of his quality. Hunter's Rembrandt probably owed more to conventional contemporary taste, as did the attractive Philips Koninck landscape which he bought on the mistaken impression that it too was a Rembrandt.

Strangely, the University did not receive any significant additions to its paintings during the rest of the nineteenth century (the Hunter items did not arrive at Glasgow until 1807). The first of the Whistler gifts came in 1935 and in 1963 the Smillie collection of twenty-nine Dutch and Flemish seventeenth-century paintings was presented. In 1970 W. A. Cargill presented half a dozen major works; and in 1971 Dr Charles Hepburn, a notable benefactor of the University in several fields, bequeathed a collection of portraits by Scots and English artists.

Other donations have greatly widened the scope of the picture collections; and the new Hunterian gallery is unusual in having also a collection of modern sculpture, some exhibited outdoors in small courts whose incorporation in the design of the covered gallery is a particularly happy feature (not least because it permits their comfortable viewing in inclement weather!).

Of these sculptors two only can be mentioned. The main gallery is entered by means of tall doors made by Sir Eduardo Paolozzi. They are worth more than a casual passing view. That is true also of George Rickey's *Three Squares Gyratory*, a mobile in the Arts Quadrangle of the old building. This last must be one of the most satisfying of near contemporary works and wins quick appreciation even from untutored eyes. In response to the slightest current of wind, its beaten steel panels move relentlessly, scooping themselves effortlessly out of the air but at what seems a varying pace – now gravely sedate, now suddenly, and inexplicably, fast; yet always graceful. The independent axes on which they turn and interplay evoke responses of wonder, contentment and excitement alike. Once engaged in its rhythms it is hard for a viewer to turn away.

The Old Masters and eighteenth-century portraits are well known enough to

RIVER LANDSCAPE BY MOONLIGHT

George Henry (1855–1943)

For long eclipsed in popular taste by his friend, Hornel, Henry was an innovative and influential painter. An awareness of the quality of his work has steadily increased with the passage of time. With Hornel he made a famous visit to Japan in 1893–4. Both readily absorbed Japanese influences but any touch of Japonisme evident in this charming painting more probably derives from Whistler and his well-known influence on late-nineteenth-century Scottish painting.

THE FISHER'S LANDING
William McTaggart (1835–1910)
McTaggart was an inspired landscape painter whose large canvasses, filled with the light of the West of Scotland and with his own unusual brushwork, led him to believe that he had anticipated the Impressionists, who were only doing "what we have been doing for years". That opinion would not convince art historians, but McTaggart does not need any additional association to make him a significant painter in his own right. The Hunterian Gallery has a good run of his works, of which this is one.

be able to exert their own magnetism; and the major holdings by Whistler and Charles Rennie Mackintosh are dealt with elsewhere but there must be room to notice the collection of works of Scottish artists, much of it assembled by the late Professor Alec Macfie. Such notice is an act of more than corporate piety for, after a long period when historians complained that Scottish painting was comparatively neglected, the last twenty years have seen an unusual flourish of interest in its creations of the last two hundred. That has had the predictable effect of taking the works involved beyond the purses and out of the parlours of most individuals, so that public collections are assuming an ever greater significance.

Alec Macfie was Adam Smith Professor of Political Economy in the University between 1946 and 1958. His art collection was built up in partnership with his brother, Major General John Macfie, but it was the Professor who was the driving

A BYWAY IN GRANADA
Arthur Melville (1855–1904)

Melville was an outstanding watercolourist, bringing to this medium an energy and even an unusual panache which made him a considerable influence with the Glasgow Boys, the West of Scotland school which responded so strongly to Whistler. (Indeed, Roger Billcliffe has called him an "honorary" Glasgow Boy.) Melville travelled extensively in southern Spain and North Africa, producing paintings which convincingly captured the bright light and deep shadows of a strong sun. He also managed the Scottish landscape well, particularly that of Orkney.

force. He was interested in paintings from student days and, as befitted someone who taught economics, always had a sharp eye for a bargain. This writer, whom he taught, recalls how he was wont to use the example of the art auction room to demonstrate the achievement of equilibrium between supply and demand! He was the most gentle and considerate of teachers.

Mary Armour, herself a distinguished painter whose work he collected, has recalled how he bought most shrewdly in the 1940s when the price of Scottish paintings was low – and artists poor. It was, however, quite possible to go on buying works of Scottish painters at modest sums until the 1970s and Macfie had sought – and taken – expert advice from local dealers like Ian MacNicol

who was faster than most to spot the quality of the group now known as "The Scottish Colourists".

Macfie bought oils and water-colours, drawings and prints. His aim was to produce a representative collection from Horatio MacCulloch onwards. He patronised living artists well, as may be gauged from the eight examples of Mrs Armour's work, eight of Sir William Gillies's and the thirteen of Joan Eardley's. Generally he bought only a couple of items by each artist in the effort to be comprehensive. Sometimes this does not matter – there is hardly any point in having

LES EUS
J. D. Fergusson (1874–1961)

One of the four friends now known as the Scottish Colourists, Fergusson lived the longest and continued painting into old age. His early paintings command most attention. This outstanding work, on loan from the J. D. Fergusson Art Foundation, compels viewing, especially close up where the confident quality of the brushwork invites comparison with the more fluid style achieved by Peploe (and by Fergusson himself in other contexts).

two Stuart Parks, lovely though his flowers are – but often one would have wished for more, in cases like Lavery, for example, who is represented only once.

There is, however, a good clutch by the nineteenth-century landscape artist, William McTaggart – five oils and a gouache. McTaggart is a most interesting painter, not least because he may have anticipated some of the techniques, though not the scientific notions, of the French Impressionists. His large canvasses catching the interplay of land, sea and light in the Atlantic coast of Scotland were one influence pulling the Colourists in that direction though they tended to catch their subjects with an even more compelling economy from more vivid palettes.

There are also twenty works by the Colourists, Cadell, Fergusson, Hunter and Peploe, a concentration which almost certainly mirrors Macfie's enthusiasm for their work. He could communicate this excitement to younger colleagues, inspiring Roger Billcliffe for instance to the study which produced his book on the four published in 1989.

The Colourists have captured headlines of late because of the soaring prices achieved by their works. There may have been an element of clever market making by some dealers in this progression which has taken some particularly

VENICE

G. L. Hunter (1879–1931)

The most erratic of the Colourists, Hunter at his best is very fine. He was particularly successful in portraying Venice, which captivated him and which he celebrated again and again. This is a happy example of his affection.

97

fine examples over half a million pounds, and which contrasts, mostly, with the straitened financial circumstances in which the artists spent much of their lifetimes. But it is hard to avoid the conclusion that unusual painterly qualities were possessed by all four.

All had direct exposure to France and were affected by French influences but all achieved their own distinct styles even where there were elements of overlap and mutual exchange of ideas, subjects and techniques, as between Peploe and Fergusson at one stage and Peploe and Cadell at another. Their versatility and facility (born of confidence in their brush work) was sometimes held against them, as if it ensured their superficiality. It now seems to ensure their enjoyment from paintings which have an immediacy of appeal and a variety of subjects from landscape through portraiture to interiors and still lives.

BEN MORE, MULL
S. J. Peploe (1871–1935)
The fourth of the Colourists, whom many think is the best, Peploe was a very versatile painter. He did not paint the West of Scotland with quite the same assiduity as Cadell, who was often inspired enough to complete an, admittedly smallish, landscape in an afternoon. But when he did paint in Iona, Peploe had an inordinate fondness for Ben More in Mull, a sentiment well caught here.

THE RED CHAIR

F. C. B. Cadell (1883–1935)

Best known for his landscapes and large interiors, Cadell's simple arrangement here evokes intense excitement from its vivid colours in striking juxtaposition. The wildness of the Fauves is evident. It was commissioned by Gilbert Innes in 1928 and presented by him to the University, along with many other paintings.

SALMON NETS AND THE SEA
Joan Eardley (1921–1963)

Joan Eardley died early while at her artistic best. She painted Glasgow children – and, to a lesser extent, its streetscapes – from a sympathetic but unsentimental eye. Her landscapes and seascapes are far more powerful. They present a very different vision of nature from the benign luminosity of the Colourists (and McTaggart, for that matter) – bleak, harsh and unfeeling. The difference in part derives from location and timing – the Colourists painted the West coast in summer; she looked out on the North Sea in all weathers, painting outdoors even in winter. In part the difference is, however, one of outlook and philosophy, her stoicism contrasting with their optimism.

The Hunterian has many other examples of the Colourists' work either donated or given on long-term loan. Cadell's splendid *The Red Chair* and Fergusson's *Royan* were presented by Gilbert Innes; Fergusson's *Woman, Flowers and Fruit* was presented by the Fergusson Foundation. Fergusson himself presented one of his paintings, and the Foundation, established in his memory by the efforts of his wife, has lent *Les Eus*. Another group of Colourist paintings is on loan from Mr George Smith, a Glasgow accountant who has built up a wide-ranging collection of Scottish (and Japanese) works. Mr Smith's generosity in lending his treasures to Gilmorehill is a reminder that the University does not need necessarily to own everything it is willing to display to its members and guests.

Any visitor to Glasgow excited by the fine holding of Colourists at the municipal gallery in Kelvingrove would find the experience heightened after a few hundred yards' stroll to this Hunterian display. *The Red Chair* should certainly

not be missed, though curiously it is not in Billcliffe's book. Nor are the "yellow" Peploes. Fergusson's *Les Eus* is reproduced there, but it really needs personal viewing if its impact is to be best felt: diminishing its size damages in some degree the delivery of its astonishing pulse and rhythm as two male nudes partner four females in happy dance. Painted with large brush strokes to achieve the almost brutal iconic style to which Fergusson often reduced the human form, this is a large and immensely powerful painting full of joy and energy.

It affords some necessary corrective to the hostile opinions of some recent critics of Fergusson's work. In the Mackintosh letters in the Hunterian's possession is evidence that he at least had a very different estimate of the quality in his fellow countryman's output. Fergusson probably never saw these letters but his own correspondence in the 1940s discloses strong efforts to ensure that Mackintosh's tea-room and its furnishings in Daly's in Sauchiehall Street were preserved for the future. He also tried pestering the *Glasgow Herald* whose, then,

STATION NO. 2 KAWASAKI
Hiroshige (1795–1858)

Like his contemporary Hokusai, Hiroshige produced many landscapes both in illustrated books and as series portraying journeys from which this example derives. Such Japanese prints were a popular art form in their own country, not always enjoying anything like the esteem they now command: the first examples came to the West as paper wrappings for more valuable ceramic exports but elicited a most enthusiastic response among European painters. The exchange between the cultures was marked but the effect on Japanese print-makers was unfortunate, and their work went into a long decline. This, and others in the University collection, represent Japanese print-making before that decline occurred.

101

MAN'S BRAIN
Edward Munch (1863–1944)

Edward Munch was a self-taught Norwegian painter and print-maker whose range of subjects, loneliness, despair, sickness and passion, was at first too emotionally intense for his contemporaries who did not think that psychological distress was a fit subject for art. He created the taste by which he is appreciated (enjoyed would hardly be quite right) and his prints are now eagerly sought by collectors. This example is one of the large number of modern and contemporary prints in the University's hands.

HOFMANSCHE SZENE
Paul Klee (1879–1940)

An artist's artist, so to speak, Klee has exerted an enormous influence, not least because of his remarkable ability to put his theories and feelings into words, something which helped make him a fine teacher. He was equally adept as a painter and graphic worker. Although Swiss, he lived and worked in Germany between 1906 and 1933 but his work was anathema to the Nazis whose notions of art were banal. This print dates from his time in Germany in the 1920s during the Weimar Republic when artistic creativity was unusually high and his own reputation assured.

dismissive attitude to the furniture designer derived from the difficulty one of its best-known scribes had in getting his legs and feet comfortably under Mackintosh's boardroom table!

Fergusson's papers are now in the University Library and will be indispensable to all future art historians of Scottish painting during and after the period of the Colourists' florescence. They include much valuable ephemeral material (catalogues and records of exhibitions as well as lists of the first prices which he set for his own work) as well as many hundreds of letters. If, however, one said that these were "a gold mine" it would have to be in the sense known to mining finance analysts where tons of rock have to be crushed to yield ounces of rare metal, rather than the popular image of nuggets or rich pannings of gold dust from a mere shovelful of soil.

The main message of the letters is to expose the devotion of Fergusson's wife, May Morris, to his memory and reputation. But they do throw some light on his range of contacts and interests; but "glints" rather than "flashes" best suggests the degree of illumination. There are some robust, if irreverent, letters from his brother and cousin. Suprisingly few from Fergusson himself display his capacities as a brilliant conversationalist which was how he struck the young Joyce Cary when the Anglo-Irish novelist met him in Paris before the First World War. No letters to or from Cary survive, and only one from Middleton Murry, another associate of the same time. But a huge range of contemporary Scottish figures does appear, for Fergusson dabbled in politics – vaguely leftist, more precisely Nationalist. In the latter case his feelings were strong, vehement even, but seldom developed beyond banal assertion.

A new biography of Cadell has shown how hard pressed he was financially; and Fergusson's letters disclose much the same strain. They also show how May Morris handled financial matters with a surer touch than her husband: it was her scheme during the austerity of the 1940s which allowed him to exchange paintings for fresh farm produce from the estate of his namesake, Sir James Fergusson of Kilkerran.

COMPOSITION V FROM SMALL WORLDS
Vassily Kandinsky (1866–1944)
Although a Russian by birth, Kandinsky trained and mostly worked in Germany where, as a "pure" abstract painter, he was an influential figure at the same time as Klee with whom he was closely associated. Like many of the outstanding painters of his time, the price of his works has soared beyond easy acquisition. Prints are more affordable; this example is in the print collection.

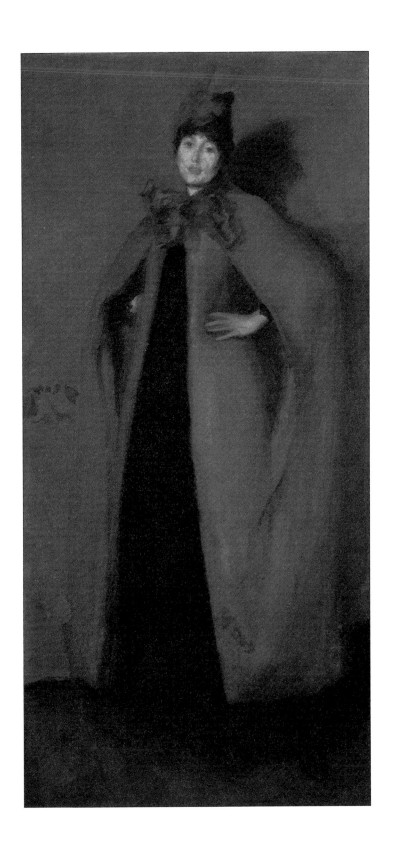

Whistler

SERENDIPITY, itself a delightful coining, describes exactly the way in which Glasgow University became the possessor of one of the two greatest collections of Whistleriana in the world.

James Abbott MacNeill Whistler, the American artist, himself had no direct connection with Glasgow. He seemed to have visited Scotland only once, but in the name MacNeill, which was not given at birth but added deliberately by himself, is one emotional hint of the Scottish identity, derived from his mother, of which he could be proud.

Even so, when he died in 1903 his personal correspondence, remaining works of art, furnishings and collections (of Chinese ceramics and Japanese prints) might have gone to the Louvre. His sister-in-law and executrix, Miss Birnie Philip, actually offered them to Paris, but Whistler himself had wanted his possessions to remain *en bloc* and the Louvre could not accept an obligation to house them all. Equally he did not want them to pass to any English institution for he felt he had been ill done by in England.

In this respect he was probably wrong: the French had rejected his first offered work whereas the Royal Academy had hung it. And though he studied in Paris and absorbed many French influences, it was in England not France that he chose to live and work, much as his contemporary expatriate Henry James. No matter, like many other men who are curiously insensitive in dealing with others, Whistler was very sensitive himself. He felt he was an outsider and in many ways he made himself one with his extravagant dress, his endless search for the *bon mot* (which could become tedious), his touchiness and spirited mischievousness. Often emotional and hard to deal with, he could as readily throw someone through a plate-glass window as double the price of a painting in response to

HARMONY IN RED, LAMPLIGHT

Née Beatrix Birnie Philip, daughter of the Scottish sculptor, John Birnie Philip, she married Whistler in 1888 after the death of her first husband, E. W. Godwin, the architect and designer with whom Whistler was friendly. She was an artist in her own right and the collection has several examples of her paintings and drawings. This warm and affectionate tribute by Whistler was executed in 1884 when the subject was still Mrs Godwin, and was an attempt to catch the way artificial light modified colour. Its ever critical creator was not quite satisfied but one contemporary viewer at least felt it to be "superb".

requests for the first price to be reduced. He was, however, always quick to iden-
tify himself as non-English and it was significant, for example, that in the Boer
War he immediately took the side of the Boers.

The city of Glasgow had been the first public body to buy a major work from
Whistler. His paintings were controversial and almost any purchase would have
seemed adventurous. The Corporation had been prodded by some influential
local painters, members of the group known as "The Glasgow Boys", to acquire
some of the work of a man whom they recognised as a force affecting their own
vision. One of the "Boys", John Lavery, was later to write in his autobiography
that "we (at Glasgow) recognised in him the greatest artist of the day and thought
of his 'Ten o'clock lecture' as the Gospel of Art". The Corporation sent a deputa-
tion of two to London to meet the artist, and these played an amusing "hard
man–soft man" haggling act to try to bid down his first declared price. Whistler
was unmoved and for £1,000 sold them the portrait of Thomas Carlyle which
now hangs in Kelvingrove. It is one of the great works of the nineteenth century
and a companion piece to the equally compelling but more famous portrait of
his mother which the Louvre, after a somewhat similar prodding of their govern-
ment by distinguished French artists, was allowed to buy a few months later for
a much smaller sum; but then the artist was flattered by the accolade of French
state patronage.

Sadly, Glasgow's municipal authorities did not also buy the fine but very dif-
ferent *Princesse du Pays de la Porcelaine* which they were offered by Alexander
Reid. Instead he sold it to Sir William Burrell who sold it on, at a handsome
profit, to C. L. Freer, a close friend of the artist as well as patron and avid collec-
tor of his work. It is Freer's superb collection which is the transatlantic peer
of that with us.

A second Glasgow connection for Whistler came later still when the University
offered the old man, as he then was, a honorary degree. He was too ill to come
to receive this directly but his letter of acceptance, preserved in the Library's
collection of his papers, shows how genuinely honoured he felt. It retains its
power to move: "In one way at least the Gods have prepared me for the reception
of such a dignity; in as much as they have kept, for me, the purest possible strain
of Scotch blood – for am I not a McNeill? – a McNeill of Barra."

At his funeral, two of the pall bearers were James Guthrie and John Lavery,

SELF-PORTRAIT

*Like many portrait painters, Whistler "did" himself often and the collection has several self-portraits. This is one
of two in the collection painted about the same time in 1896. Somewhat more subdued than his more romantic
and exuberant conceptions of himself, it is still assured and confident. It was in his studio at his death and, though
more finished than its companion, may have left Whistler unsatisfied. He constantly changed and improved his
work – often to the fury of the subjects. Margaret MacDonald certainly thinks part of the face here was "in process
of being changed".*

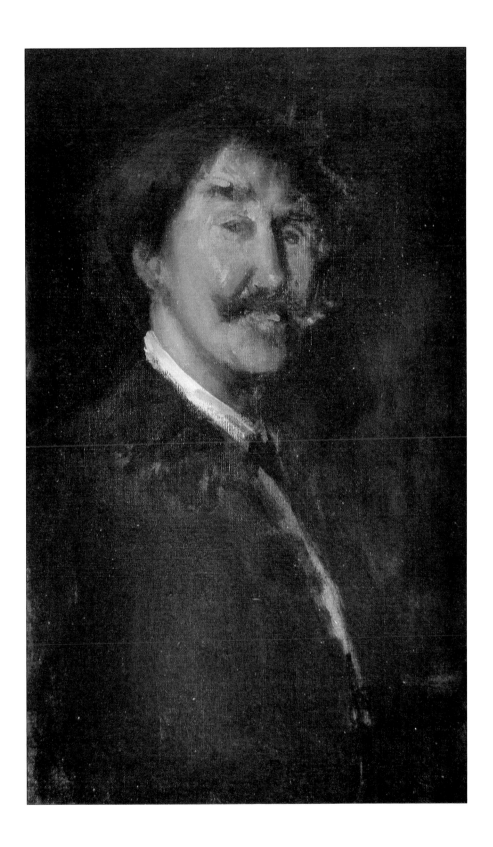

distinguished Scottish painters of the group instrumental in getting the Corporation to buy Carlyle. These intimations of Glaswegian respect and affection even, stimulated Miss Birnie Philip's eventual decision. In three separate tranches beginning in 1935 she presented such a body of material as made the University the natural focus for the work, originally begun under Andrew Maclaren Young, which led to the scholarly catalogue raisonné of his paintings published by Yale in 1981. This triumph of art publishing – for Whistler's uniquely low-toned palette makes great demands of printers – exposes the extent of the Glasgow collection of oil paintings, and in particular its appeal to art historians. The collection covers nearly all aspects of his career and development but especially his later years.

It is possible to see from many of the unfinished works which were in his studio the progress of his technique. Contrary to the impression his "nocturnes" in particular made on some contemporaries, Whistler's work was deeply considered. The fellow student who early dubbed him "the idle apprentice" was very far from the mark. Perhaps the young Whistler enjoyed conveying an impression of effortless superiority, but in fact he took remarkable pains, and could wash out and repaint portraits up to ten times. He was a perfectionist and made unusual demands of sitters: his demands could reduce a child subject to floods of tears which left him unmoved for all that he was fond of children. His insistence that only finished works could leave his hands enraged many sitters and cost him commissions.

Whistler's intense desire to get everything right made him devote much unusual attention to the framing of his work and to its hanging and setting. He was automatically, it might seem, an interior designer; for the sense of harmony, derived from the Japanese, which so informed his landscape paintings, extended to the location in which they would be shown and the furniture which should accompany them. It was a combination of his passion for perfection with a self-confidence bordering on conceit which led him to create the famous Peacock Room, an early design for which is in the Glasgow collection. The room was originally in the London house of an absent patron, F. R. Leyland. Its eventual creation was engineered almost without consulting him. The outcome, now hailed as a masterpiece, was loathed by its owner: it spelled the end of a close friendship. Whistler was indeed a master of "the gentle art of making enemies".

With the paintings came a collection of pastels, a medium in which he proved

GREY AND SILVER: THE THAMES
Painted about 1872, this is one of a very large number of studies of the river in all its moods which Whistler made throughout his artistic life. He was preoccupied with the river and the play of light on its surface. This highly effective monochrome treatment, calm and cool, with its images melting into the land and riverscapes evidently appealed to Whistler himself: he made a lithograph of the same view in 1896, and an even closer lithotint.

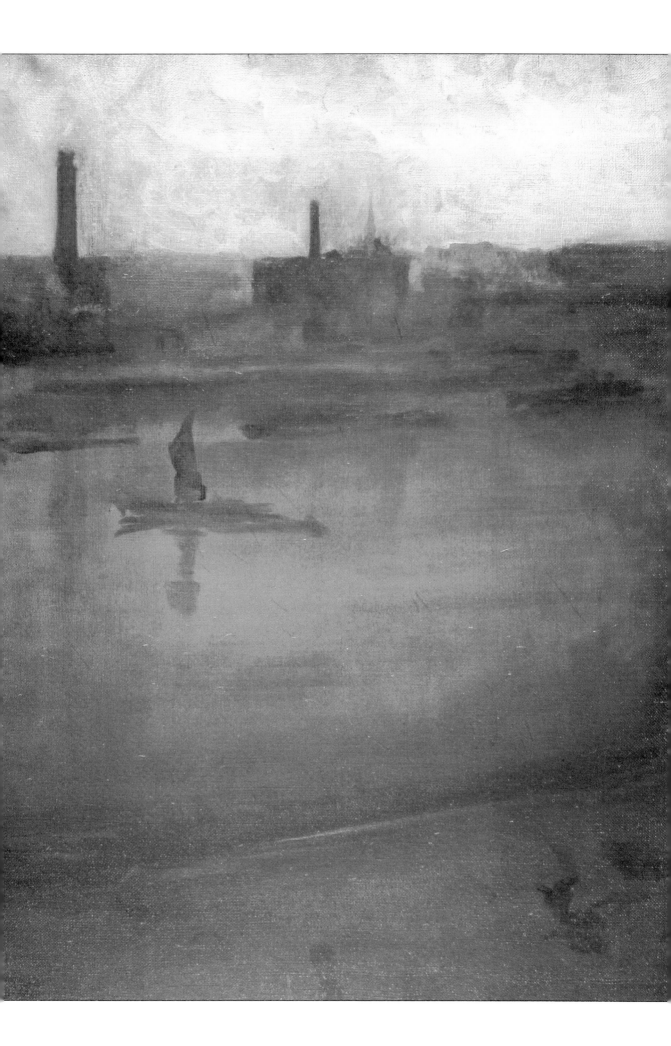

singularly adept. Many who found Whistler's oils initially so hard to take were immediately engaged by his pastels, a fact which proved a boom to him when, after his bankruptcy in consequence of his famous law suit with Ruskin, he had had to live very modestly. During his self-imposed exile in Venice he produced a goodly clutch of pastels, as well as a very few fine "nocturnes", and the former were quickly sold for 1,800 guineas when he made his flamboyant return to London. The pastels show how fine a draughtsman Whistler was and may be said to confirm his view that colour is subordinate to drawing, though their colours too are wonderful.

The Birnie Philip material also included a huge collection of etchings where Whistler was always indisputably hailed as great, and late in his life with a great Dutch series, as being in the same class as Rembrandt. All the stages of his development as an artist are visible in the etchings for he used the medium throughout his career. The collection has many rarities: there are, for example,

THE ARABIAN

This pastel of 1892 has many echoes of the fascination of the female form in European art. The quality of Whistler's draughtsmanship is celebrated here with considerable eclat. The delicately scintillating colours and patterns of the background and foreground afford a foil to the voluptuous massing of the body in calm repose. It delivers enchantment.

THE GREAT PINE TREE AT AOYAMA
Katsushika Hokusai (1760–1849)
This is one of the Japanese prints owned by Beatrix Whistler, and part of the Birnie Philips donation since Beatrix predeceased her husband. Whistler himself was one of a large number of nineteenth-century European artists who were strongly influenced by Japanese work, in particular the popular art of the print-makers. Hokusai, one of the masters of that genre, is particularly interesting, for he, in his turn, absorbed European influences (in perspective, for example).

all of the famous late Amsterdam set, none of which was actually published. At a time when etching as an art medium, and an easily collectible one, is fast coming back into fashion after nearly a half century of relative neglect, Glasgow's Whistler holdings are bound to assume even greater prominence.

Although the Glasgow collection in this area of his work is not absolutely complete (additions are still being made), the original gift of graphics was in such profusion as to include numerous duplicates and for a time many of these were sold or exchanged to augment the University's collection of Old Master prints which is the largest in Scotland.

Whistler himself was also an avid collector of Japanese prints (like many contemporaries he was much influenced by Japonisme). As with his Chinese porcelain, however, it is possible that all or most of the first holdings were sold following his bankruptcy. Those given by Miss Birnie Philip actually belonged to Mrs Whistler who predeceased her husband. He might anyhow have given them originally to her (possibly to avoid their being sold off to meet the demands of his creditors). They include three attractive Hokusais, but generally they are

not the best of their kind and have suffered somewhat from unguarded exposure to light. The rest of the University's small Japanese print collection has fared better, but no great claim should be made for it.

Whistler's standing as a major painter has been subject to some significant ups and downs. His reputation was very high when he died in 1903 but quickly suffered an eclipse when it appeared that his vibrant personality had, perhaps, been of more import than his actual work. That opinion was only slowly reversed but has eventually been replaced by a high estimate of his artistic worth, and of his influence on American painting right up to the near contemporary scene (those who enjoy Mark Rothko's work, for example, will find Whistler's influence evident).

He was, of course, influential in the United Kingdom, though, it would appear, somewhat less so in France. One minor but interesting Scottish figure who was strongly affected by Whistler's etching was James McBey, the self-taught artist from Buchan.

McBey produced an unusual and striking volume of early autobiography (which did not appear until 1977, eighteen years after his death). Its somewhat bleak and quirky portrait of what was clearly a very hard young life is modified by a small clutch of forty of his letters which the Library's Special Collections recently acquired from a Los Angeles bookseller. These were written during and after the Second World War, to one of his former models living in the United States, of which McBey himself became a citizen. They disclose a more relaxed and even charming personality, obviously fond of his correspondent and always interested in her various artistic and business ventures.

These letters contain some material on his ideas about the use of paint, and are often illustrated by little drawings but nothing of much consequence in that regard. They do offer some oblique commentary on wartime and post-war austerity in London (though the McBeys avoided the worst by living in Tangier) and might be mined modestly by future social historians who will relish the response from a London art supplier when McBey was rash enough to ask for egg-based tempera: "Egg? If I had an egg, I'd eat it!"

McBey's first etchings and portraits were produced in Aberdeen and connoisseurs of irony will enjoy his remark (in a letter of 1958) that the famous municipal gallery there had bought none of his work. His widow deposited his books and papers there, and one of its glories is now "The McBey Room".

Charles Rennie Mackintosh

THE MACKINTOSHS' house was originally at 6 Florentine Terrace, later known as 78 Southpark Avenue, in Hillhead. They moved there in 1906. Mackintosh reworked the attic and added a new front door but otherwise altered little in its externals, except to insert windows in the south-facing gable, a change which greatly increased the natural light inside. The eventual loss of the fabric of the house therefore took away little that was structurally his creation. Nearly all of his work was inside where he wrought considerable change not just with his individual colour schemes which were quite distinct from those prevailing at the time, but in respect of all important details such as doors, fireplaces and light fittings. Like Whistler, Mackintosh had a powerful decorative imagination and a passion for perfection. His rooms are works of art conceived as complete statements of his own, and his wife Margaret Macdonald's taste and design, with nothing left to chance – reputedly even their cats would be catered for with matching cushions on either side of the drawing-room fireplace.

Given that the Hunterian Gallery was itself an entirely new construction, the Mackintosh house could be recreated in its original vertical style and not just as a series of three-sided rooms, each a museum piece but inescapably false and advertising that fact by their separation. The new building does not reproduce the ashlar sandstone façade of the Victorian terrace. That would have screamed at odds with the poured concrete of the rest of the gallery; but the essential sculpture of the original is there, looking somewhat strange in its present location above the street level: "an exclamation mark!" says a friendly critic; but "absurd" has been heard as well.

What emerges inside is the feeling of the house's original integrity as a place for living, albeit an unusual place. It is a tribute to the modern architects' skill that this impression has been achieved without abandoning air conditioning with the concomitant temperature and humidity controls essential to the well-being of the furniture. The conditioning has been infiltrated with such discretion that it is not noticeable to normal inspection.

Mackintosh left Glasgow for England in 1914 and later sold South Park Avenue with the greater part of its contents to William Davidson, one of his earliest clients and most loyal supporters, in 1919. Davidson seems to have made

minimal alterations to the interior thereafter, and after his death in 1945 his sons, Hamish and Cameron, presented most of its furnishings to the University which had purchased the property.

The decision to demolish the house was not lightly taken and, before it was demolished, the interiors were carefully measured and all movable items including panels, skirting and doors were saved, to be rebuilt within the gallery. These details, with the furniture all to Mackintosh's design, ensured that the main rooms – the hall, the dining-room, studio-drawing-room and main bed-room – could be re-established in near perfection. The qualification is required, for though much study went into the recreation, no contemporary photographs of the house survive from the Mackintoshs' time (the earliest date from 1933) and it was only in 1963, just before demolition, that the sort of detailed record academics would prefer was actually made. The house, as seen today, cannot be quite what Mackintosh knew, but it is as close as honesty and painstaking endeavour can manage. The result is wonderful.

Mackintosh could not change the proportions of the hall but he did take away the entrance vestibule and altered the fenestration to admit more light, thus creating an illusion of space. In the dining-room he fitted taller doors, and added a broad picture rail above which a white frieze and ceiling enhance and emphasise the darker lower colour scheme. The ceiling floats away into light. Reconstructing the actual decoration of the lower areas involved some guesswork as only two lengths of the original wallpaper survived (and these had been partially overpainted). Much thought was required before the present scheme was achieved and the furniture positioned. The high-backed, stained oak dining chairs are among the best known of Mackintosh's designs, their tall elegance, without historic precedent in European chairmaking, evoking for many the most familiar image of his furniture. Of the six examples available in this room, two are reproductions made to the most detailed specifications by the Italian firm of Cassina, Milan, which has specialised in the field of recreating furniture by masters of modern design.

Almost certainly, had Mackintosh possessed the financial resources he would have built his own house from scratch. His insistence on getting the detail exactly right – on one occasion at The Hill House, even down to the exact colouring demanded of slates for roofing – would have required that. Southpark was the next best thing, and it was in its studio-drawing-room that Mackintosh made his most thoroughgoing and transforming changes, knocking down a wall to make two rooms into one, integrated successfully by simple devices like a common picture rail. Increasing the window area provided additional light whose effect is further augmented by the all-white decoration, including the white fitted carpet. Muslin curtains filter and soften this light; the resultant effect is remarkable and far removed from the darksome interiors of most Victorian equivalents.

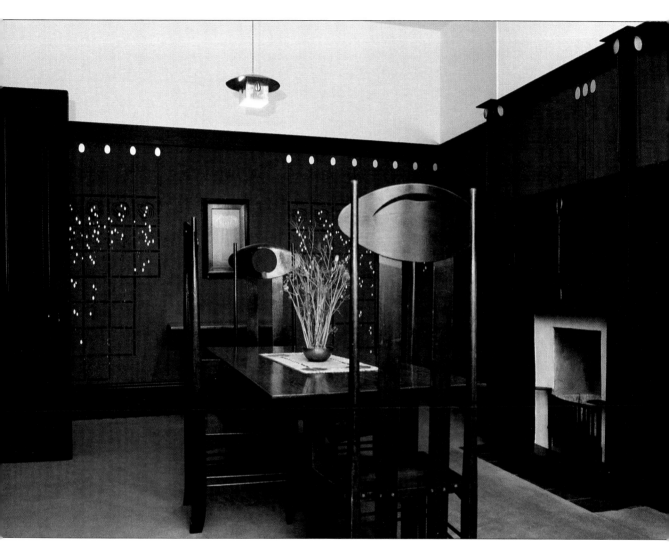

THE MACKINTOSH HOUSE
Dining-room

Few alterations were made to the dining-room, and its decorative scheme was developed from that established in Mackintosh's earlier house in Mains Street. The wallpaper is a reconstruction from two surviving lengths and much thought was given to how the design would relate to the furnishings when in place. These latter include the visually splendid high-backed chairs which Mackintosh originally designed for the Argyll Street Tearooms. Of the six seen here, four are originals, two are on loan from the School of Art and two were presented by Hamish and Cameron Davidson in 1946. The two replicas are examples of the work of the Italian firm, Cassina.
The serving-table and sideboard, dating from 1900 and 1896 respectively, were presented by Hamish Davidson in 1972. The sideboard is possibly the first item designed by Mackintosh for his own use.

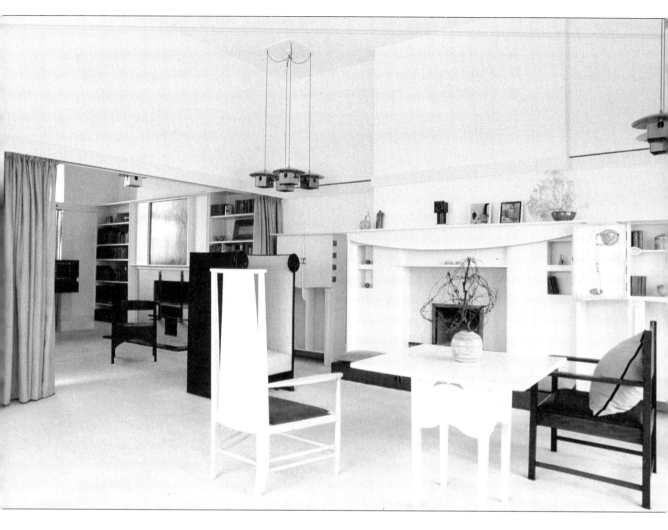

THE MACKINTOSH HOUSE
Studio-Drawing-room

This wonderful room is full of light. Its large space incorporates two rooms which Mackintosh knocked into one. He added to its light by enlarging a south-facing window and by providing an all-white decorative scheme. The furnishings of the room are all of interest but the writing cabinet of 1904 is especially noteworthy being made by Mackintosh for himself, a slight variant of that which he designed for Walter Blackie at The Hill House, Helensburgh. It was purchased in 1979 through the combined efforts of numerous state, charitable, corporate and individual donors.

Even with few other testimonies, this room would ensure Mackintosh's reputation as a great interior designer. Every detail is calculated – nearly all of the original detail and fitments were replaced by his own.

Mackintosh used his home almost as an office and store for his finest pieces – those which he would exhibit, and those from which his European reputation first derived. The studio-drawing-room holds, for example, the splendid writing cabinet dating from 1904 which the University acquired in 1979 for £80,000. It had sold previously in 1933 for £10. This piece – mahogany inlaid with pear wood, ivory, mother of pearl and leaded glass – was based upon a design for Walter Blackie, the publisher. It is a major work of European art, an opinion which fits the Mackintosh house as a whole. It is its ambience as much as individual items or decorative devices which encapsulates the artistry.

The gallery holds also the Mackintosh archive which came from the artist's estate in 1946. The 600 drawings cover the whole span of his career and are essential to any scholarly appreciation of his work. The material involves the whole range of his interests from architectural and furniture and interior schemes to designs for textiles, graphics and decorative art objects. There are about 200 architectural drawings and almost the same number of furniture and interior designs. This remarkable archive was preserved by the agency of William

THE HILL HOUSE, HELENSBURGH, 1903

South Elevation, Principal Bedroom

The Hill House was built between 1902 and 1903 for Blackie, the Scottish publisher. Like his other major domestic building, Windyhill in Kilmacolm, it shows how Mackintosh was able to combine traditional school architectural modes with his own unique vision. Seeing Windyhill convinced Blackie that Mackintosh was his man. The outcome of his commission is far from the pastiche of some of the architect's immediate predecessors and contemporaries who also exploited traditional forms. Instead, there is something new, and distinctively and excitingly modern, for all the echoes of the past.

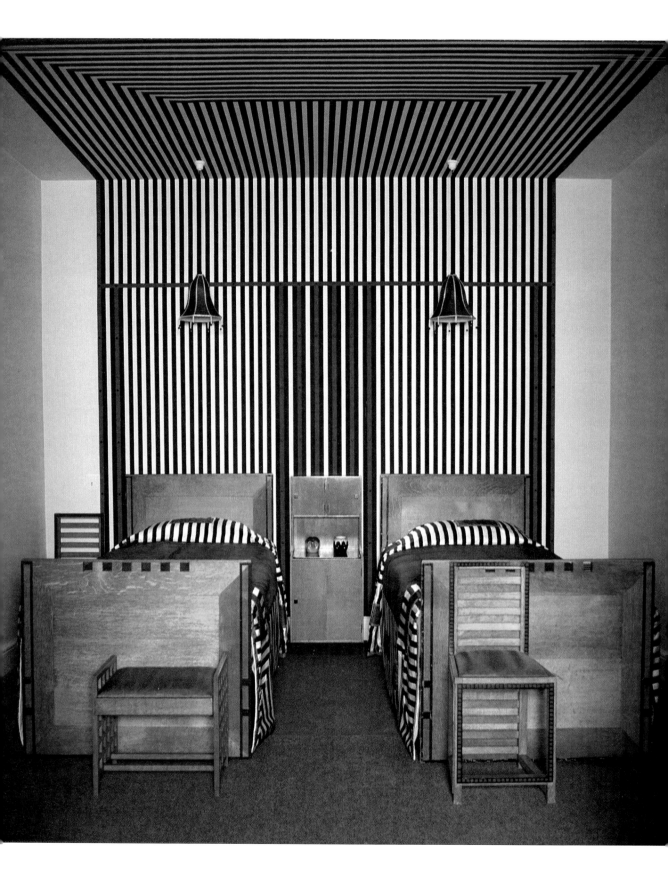

Davidson after 1933; and transferred to the University by his sons, Hamish and Cameron Davidson, after their father's death.

Included in the archive is a group of his letters to his wife in 1927 which discloses how financially straitened was their later life; and how very much he depended on her love and companionship. Less intimate but scholarly invaluable material is also involved, ranging from contemporary periodicals and photographs relating to Mackintosh's own career and those of his closest associates in the Group of Four.

There are also thirty-three examples of his flower paintings, the largest single holding of these beautiful creations which testify to the diversity of his talents. Mackintosh seems to have drawn plants and flowers from a very early stage, although the first sketchbooks are lost. He turned to still-life flower composition, and indeed to highly distinctive landscapes, later in his life because he needed money when his income from architecture and design faltered badly. Not much came in from this source, though William Davidson was an important buyer, responding to a Mackintosh letter of 1919 which admitted "frankly, I am very hard up". The asking price for the works Davidson was offered was £20 or £30 apiece. Though much larger than it will seem to modern readers whose sense of the worth of a pound has been eroded by inflation, such a price was modest. Davidson seems to have acquired quite a few and the core of the present University collection is his donation of thirteen items made in 1933, a number doubled in 1947 by Mackintosh's heir.

In fact plant form was a vital element in all his work. The decorative impulse dominates the flower paintings. Some have identified a Japanese influence but it seems slight. Even the much stronger tradition of European scientific botanical illustration which permeates many of them is sometimes subordinated to purely decorative considerations; though Pamela Robertson, who has written the commentary to the University's published catalogue reproduction of all its flower paintings, points out botanical "errors are extremely rare".

Mackintosh's painting takes second place to his buildings and furniture but for all three the starting point for more than a casual understanding is now on Gilmorehill, thanks in great measure initially to the generosity of the Davidson family.

78 DERNGATE, NORTHAMPTON, 1919
Guest-bedroom furniture
Nearly 600 original Mackintosh drawings and designs were presented to the University in 1946 by his nephew and heir, Sylvan MacNair. These are housed in the Mackintosh gallery, which also contains, on permanent display in a reconstructed room-setting, the furniture from the guest-bedroom, 78 Derngate, Northampton, which Mackintosh designed in 1919 for W. J. Bassett-Lowke. Essentially austere design makes an exciting impact with its linear and geometric forms. The grained wood is left as much as possible to speak for itself with reinforcement coming from blue and black edging.

121

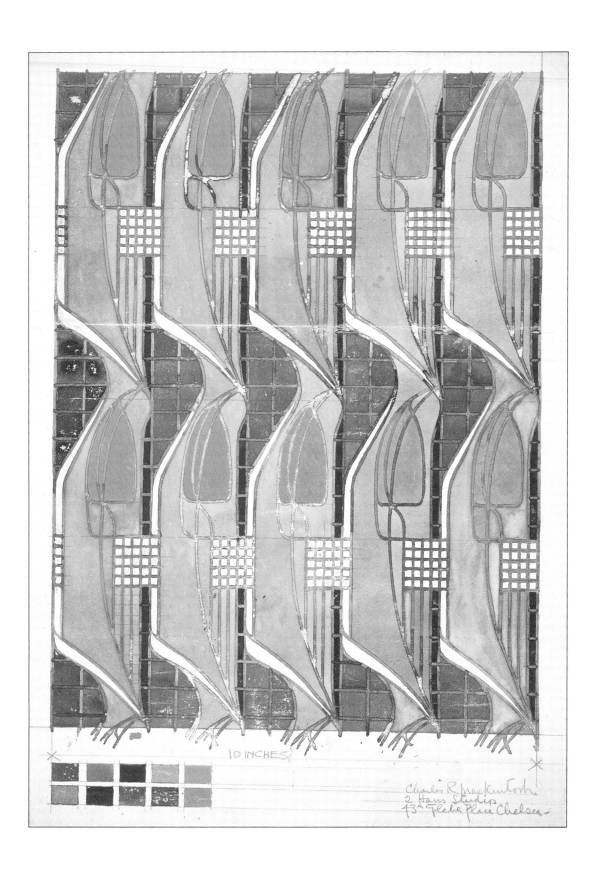

10 INCHES

Charles R Mackintosh
2 Hans Studio
73ᵈ Glebe Place Chelsea

LARKSPUR, *1914*

*This highly decorative rendering of a fairly common annual was one of the forty or so flower drawings Mackintosh
produced during his stay at Walberswick in 1914. His intention of publishing or exhibiting these on the Continent
was frustrated by the outbreak of the First World War. Shown for the first time at Mackintosh's memorial exhibition,
these were then acquired by Mr William Davidson, who presented them to the Botany Department of the University
in 1933.*

TULIP AND LATTICE

Textile design, c. 1915–23

*Another of Mackintosh's loveliest achievements, this design shows how his architectonic vision and knowledge of
plant structure could fuse to produce something original and yet convincing.*

THE LITTLE BAY, *1927*

*This is one of a number of highly distinctive water-colours produced after 1923. All are unmistakably Mackintosh
and are informed by an architect's eye in their flat planes and lines. Yet they transcend the necessary limitations
of architectural drawings and are, in the words of Thomas Howarth, the pioneer of Mackintosh studies, "as extra-
ordinary as . . . unexpected".*

*The Little Bay is calm and restful; others of this time have more force. All send echoes of Japanese art, though
usually it is Cezanne whose influence is detected in works which are in fact highly original.*

SUMMER

Margaret Macdonald, c. 1894

Margaret Macdonald was an artist in her own right, although nothing much is known of her early training. Her style was certainly well established before she came to live in Glasgow with her husband. This is a design for a stained-glass window (for which she had just won a competition: it may have been her winning entry). The stylised male and female forms are noteworthy.

ROSE-BAY WILLOWHERB, *1919*

So common is this plant, widely dispersed along the margins of rail and motorway development, that it is usually dismissed as a weed – "a plant for which mankind has yet to find a use", in Thoreau's words. Mackintosh drew and painted this splendid specimen (and the flower of one other unidentified plant) at Buxted in Sussex in 1919. It is one of only a handful in this format produced after he left Walberswick in 1915.

SCOTTISH MUSICAL REVIEW
POSTER, 1895

The Scottish Musical Review *was a short-lived periodical published in Glasgow. Mackintosh designed two posters and these assured the journal of a place in history. Their powerful stylised, linear imagery roused something of a furore when first seen. Modern viewers will be more stimulated than shocked by the quality and impact of this design.*

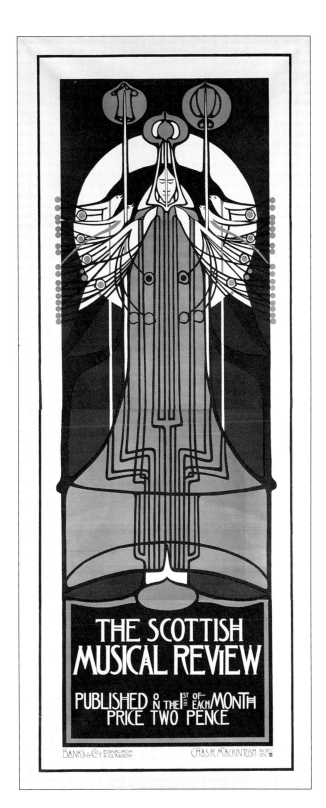

THE MACE OF GLASGOW UNIVERSITY
This lovely creation and badge of authority dates from the University's earliest years: in 1460 the Rector, Mr David de Cadzow, gave twenty nobles towards the making of a university staff. That there is no proof that its makers were Scots need not by itself disqualify a native origin. Although work of this quality would be extremely rare in a small and poor country like fifteenth-century Scotland, the fact is that the skills were available when, at a somewhat later stage, the Mace required repairing. It was then further embellished by the local craftsmen involved.

Silver

GLASGOW SILVER is not a mighty hoard to be guarded by some academic Smaug. It was not even until recently gathered together in one place. It may never have been "burgled", as was Smaug's in Tolkien's story, but it did suffer one largish loss when the move from the Old College to Gilmorehill took place in 1870. A box of plate, purchased for £42 in 1832, simply disappeared.

What has survived is mostly better than good and often interesting, even if it is now probable from the evidence of its hallmark that what was long thought to have been Dr Johnson's pipe was made almost a decade after his death. That is a pity. A direct link with the famous scribe would have been most welcome since he may have been the source of William Hunter's decision to leave his treasures to the University. The two were certainly close friends – so close that when Johnson out of shyness could not bring himself to offer one of his books to the King it was Hunter who stepped in to do so on his behalf. Hunter had much earlier told his medical friend and mentor William Cullen that he intended to do something for Glasgow but it was not until his plans for a state-sponsored museum in London were rebuffed that his mind turned again homewards. Johnson's advice may have clinched his decision.

There are, however, other interesting literary associations with this particular pipe for it was presented to the University's Ossianic Society in 1931 by Sir Compton Mackenzie whose grandfather had acquired it much earlier: it must be more comfort for Scots to recall the fun and laughter of Compton Mackenzie's *Whisky Galore* and its companion novels, rather than the doctor's harsher observations even where moderated by Boswell's patriotism.

Considerations of patriotism did not prevent Archbishop Beaton taking the University mace with him when he fled to France in 1560. It is something of a miracle that it returned home thirty years later. It was not unscathed as it had to be repaired and at that point additions were made to its design. It dates from the 1460s and was a costly purchase for the University, advertising the dreams of the early founders.

Where the mace was actually made is unknown. Lady Williams, who has most recently devoted long scholarship to the silver collection, suggests France as "its most probable origin" but other locations have been put forward including

THE LOVING CUP

A large beaten-silver bowl on a pedestal with a round foot, this cup, dated Edinburgh 1659, contains metal of somewhat similar origins as the Mace. It is an imposing piece of fine sculptural quality and inspired a replica made by Edwards of Glasgow in 1935. There is no information about the replica's donor nor even of its making, for the records of Edwards seem to have been lost following its takeover by a larger group.

Scotland itself. In the absence of certainty, a native origin should not be rejected. The later additions made to its original design would almost certainly have been local.

The mace discloses a high quality of decorative skill. Other early pieces in the University's possession derive their considerable visual impact from their sculptural quality rather than decoration. The Loving Cup, made in Edinburgh in 1659, is a particularly fine piece – handsome, weighty but well balanced – and in its simplicity pointing the way ahead to the domestic Scottish silvermakers of the eighteenth and early nineteenth centuries. This cup replaced an earlier vessel dating at least to the 1580s whose own metal seems to have gone into the making of the successor. (There is also a replica made in Glasgow in 1935 and presented to the University by an anonymous donor.)

A quite different, and later, style of silvermaking is evident in the large cup made for William Hunter by John Swift in London in 1760. The silver collection is not dominated by Hunter's munificence but this is undoubtedly a splendid example of Georgian craftsmanship with its elaborate embossing and fine pictorial celebration of an anatomy lesson: a cadaver lies exposed on a table while an attentive audience looks on. This could have been Hunter, in his brother's words "the father of British anatomy", at work.

Adam Smith figures in the silver collection too, with some spoons made by Patrick Robertson in Edinburgh between 1777 and 1782. There are twenty-five in all: a large serving spoon and a dozen each of soup and dessert spoons. All bear the monogram "A.S." and were offered for sale to the University in 1968 by a gentleman in South Wales. No record of the valuation placed upon these spoons or their actual purchase price survives. Nor can it be absolutely certain that the "A.S." is who the seller claimed – there was no accompanying documentary proof. The probability is, however, so strong as to be convincing. The hallmarks coincide with the years when the financial success of *The Wealth of Nations* would have allowed Smith to make such substantial purchases. Those in search of relics of the great man will need little convincing that these objects were indeed his.

An indisputable provenance attaches to the two items in the collection associated with Professor John Glaister who followed his father of the same name in the chair of Forensic Medicine in 1931. They were given to the University by Mrs Glaister in 1971. One is the silver cup, awarded to Glaister as the Swiney prize in 1949. The other is a rosebowl which has the more interesting historical associations, being the Swiney prize for 1939 awarded to Glaister and his colleague Professor J. C. Brash for their work in the famous Ruxton murder case. The pair were able to establish that scraps of human tissue found near Moffat in the Scottish Borders came from the dismembered bodies of two women, the wife of Dr Buck Ruxton and her nursemaid, Mary Rogers, evidence decisive in determining the doctor's guilt as their murderer.

The Ruxton case made a vivid impact on the contemporary imagination (one that long survived in a well-known street song recorded by the Opies in their *Lore and Language of Schoolchildren*) but the bowl has more than associations to recommend its viewing. Its maker was Henry George Murphy, who, unusually for a silversmith, was elected to the Court of the Goldsmiths Company in 1939. Lady Williams thinks this attractive piece may have been the last he made: it is hallmarked London 1939, the year of his death.

Other items whose interest is wider than their precious metal content or design might suggest include a three-piece butter dish engraved with a Campbell crest and made in Edinburgh by John Mackay in 1831 to commemorate the life of Lockhart Muirhead who was one time Professor of Natural History in the University. The dish was presented to the University by the late Sir Patrick Muirhead Thomas, a descendant of Lockhart Muirhead and of James Watt, the engineer, and Matthew Boulton, his associate, who both had Muirhead connections.

There are many other pieces of interest including a collection of modern commemorative pieces brought together by Dr and Mrs James Heggie. As with all the material assembled in this book, these remarks provide little more than a taste of treasures rather than a catalogue or exhaustive assessment. In the case of the silver collection a fully detailed catalogue has now been prepared by Lady Williams. Anyone who responds to that fascination which precious metals exert on the human mind will want to consult it both for its curiosities, like the Wellington wine wagons, and its odd individually fine pieces, like the Jensen Tazza, which considerations of space have squeezed out of this brief gallop. What makes its assembly most compelling is neither the inherent nor even antique value of its constituents but the fact that all of the silver relates directly to the life of the University or of its graduates and teachers.

WILLIAM HUNTER'S CUP

Made by John Swift of London in 1760, this ornate piece of English Georgian silver presents a marked contrast to the more severely restrained Scottish domestic style of the two previous items. It was part of the Hunter bequest and came to him in 1761 when his medical students presented it in relief at his rescinding a decision to end his lecture courses.

133

Ethnography

LOVERS OF folk wisdom will recall the adage "Keep a thing for seven years". The implication is that by that time what might at first have seemed worthless will have acquired utility. It took much longer than seven years for the early ethnographical holdings of Glasgow University – and indeed other academic institutions – to attach to themselves a sense of worth other than that associated with the merely curious. The switch in awareness occurred in very recent times though its roots can be traced back to the late nineteenth century when the British, and German, governments proved anxious to acquire superb brass sculptures from Benin in what is now Nigeria. Somewhat later, the influence of such material, particularly of sculptures, on Western plastic arts began to make itself evident.

Some Western academics were always interested in the material culture of what were once referred to as "primitive societies", but it took time for their views to command general acceptance. By the time that had been achieved, many of what have come to be better described as "small-scale" societies had more or less ceased to exist (Papua New Guinea was one of the last havens to survive relatively untouched into the modern world: needless to say, its peoples and social structures are now under assault). Their demise was seldom intended. They were simply overwhelmed by the superior material culture of the West, its cheap mass productions as well as its systems of thought and assumption, its cultural aggression. This process began surprisingly earlier and has proved to be so relentless that Alan Morehead, writing in the 1960s of the swamping of Polynesian society, believed that only something akin to apartheid might have saved it, a thought to evoke much discomfort in European minds.

These profound changes have eventually lent great academic significance to material which has been preserved almost untouched for more than two centuries. It might also be noted that the switch in regard for the creations of

A MAORI IDOL

This is also probably from Cook's voyages since it is mentioned as one of a pair in Laskey's catalogue of the Hunterian Collection of 1813. Its exact function is uncertain but is likely to have been ornamental and used externally in house contruction.

primitive peoples has resulted in a spectacular monetary appreciation of such items and collections as are offered by the auction houses. The sale of the Hawaiian and Maori collections of James Hooper in 1977 and the Meulendijk collection of Tribal Art in 1980 were important cases in point. It would now be extremely expensive to build collections of such objects: it is reassuring to note, therefore, that the Glasgow collection has survived almost in its entirety, and even been added to since its beginnings.

As with so much, the story starts with William Hunter who seems to have snapped up (as did his brother John) anything which could be bought from the returnees of the three Cook expeditions to the South Seas between 1768 and

A MAORI KNIFE
One of the finds of the Cook voyages bought by Hunter, this domestic, not military, knife was probably used for cutting meat. Made from a single piece of wood, with shell ornamentation, the cutting edge is supplied by sharks' teeth (likely to be very sharp).

NOOTKA INDIAN BIRD RATTLE

Cook material again from the third voyage which reached up to the North-West coast of North America to what is now Alaska. The stones which allowed this hollow wooden rattle to sound have long disappeared. Its function was almost certainly ceremonial: when local chiefs appeared to greet the Resolution, *Cook's ship, their speeches were sometimes punctuated by the shaking of such rattles.*

PATTERNED BARK CLOTH FROM TONGA

For all that it looks like "cloth", and is usually described as such, this material is not woven but beaten out from the bark of a tree, much like felt is beaten from animal hair. Its source was the Paper Mullberry tree, and the pattern was stamped on.

TONGAN PROVISIONS BAG
A woven bag made of coconut fibre and ornamented with shells, the very old label on this item identified it as coming from Amsterdam Island, the earliest European name for the Friendly Islands. It is almost certainly from Cook's first or second voyage.

SCALE MODEL OF A KAYAK
This attractive model came from Cook's third voyage and is an example of Eskimo work. It might have been made as a toy but its precision is unusual. Although only one figure is present now, it is, in fact, a replica of a two-man vessel, a baidarka.

1780. The expeditions arrived back in the United Kingdom in 1771, 1775 and 1780, the very time when Hunter's medical reputation, and hence professional income, were at their highest. Since his scope of interest was so wide he acquired many of the objects most contemporary observers were apt to dismiss as not being of scientific interest at all. They wanted plants, shells, insects and animal life. Hunter did not despise these, but seems eagerly to have bought what others rejected, particularly weapons and hunting implements. He bought much Cook material both immediately and later at auction; and he seems also to have bought separately material which originated in the Indian communities of Canada between the Great Lakes and Hudson's Bay.

The geographical scope of Hunter's collection is therefore immense – adding a large stretch of western North America to the eastern half of the Pacific basin from New Zealand to the Aleutians, including the coasts of Alaska, British Columbia and Tierra del Fuego. Its holdings are what professional ethnographers call "first contact" indigenous material, owing nothing to European modes or techniques. This pristine element is highly prized; and not least because such things did not long survive unaltered the force of cultural exchange (to put it benignly) that followed contact with the West.

The original trustees of William Hunter's bequest were meant to produce a complete inventory of all the collections. Their failure to do so was not systematically corrected when the materials arrived in Glasgow. As noted elsewhere, however, in 1813 Captain John Laskey did produce a detailed list of the exhibits in the new Hunterian museum which Glasgow had built to house

TAHITIAN GORGET
This U-shaped wickerwork gorget, part of Hunter's Cook material, was worn by chiefs, possibly as their symbol of authority.

NOOTKA SOUND INDIAN HAND-CLUB
A whalebone hand-club carved in the form of a bird's head, this lethal weapon was the sort of thing which Hunter
snapped up, in this case from Cook's third voyage.

Hunter's treasures. Laskey's work has many deficiencies, including lots of factual errors; but from a long list of what he described as "a great collection of curiosities from the South Sea Islands" it has proved possible to make a detailed reconstruction of the purely Hunterian donation before it was reinforced in 1860 by the inclusion of much Polynesian and Melanesian material originally acquired by the Revd Dr George Turner, a Scots missionary. It is now clear, for example, that Hunter's donations in this field included more than 200 individual items, all of a "first contact" nature.

The Pacific island societies which were first visited by Cook were Stone Age communities. They were settled and had domesticated plants and animals; but they did not use or work metal. Their implements were of stone or wood, as were their weapons. They had not fully developed weaving but they had developed looms and knotted individual pieces of fibre to produce "cloths". Some of the Maori cloaks in the Hunter material show how this technique could produce fine adornments, functional as well as decorative, as would be expected from New Zealand's climate. Visually not as splendid as the great feathered cloak from Hawaii in James Hooper's collection, these are still very attractive, as are many of the examples of bark cloth from various of the South Sea islands.

The carvings are notable. Here not just Maori work is outstanding. The Nootka Sound Indians produced especially fine items and it is now known that their handiwork in this collection came from Cook, as did examples of the very different Eskimo work of which the scale model kayak is a charming representative.

Not all of this material was previously on display and at one time only a relative handful of specialists might have been expected to enthuse over it. So much so that one Glasgow Professor was recently wont to dismiss it as "bits of fur and feather". His opinion should not be thought too idiosyncratic: the ethnographical section of the British Museum used to be known as "the rag and bone department". All that has changed. A more popular awareness of these creations may have been long overdue, but it has now arrived.

The Library

A RECENT Reith lecturer suggested that the novel was the main characteristic of Western culture. The book, more generally, might be an even better bet. It is true that the West has no monopoly of book production which, in its present form, seems to have begun in Egypt, during the first few centuries AD. The greatest proliferation of books, however, occurred, and continues to occur, here. The tide of production shows no sign of slackening in spite of the rise of new systems for recording and storing data. Such systems may represent the future, but guardians of existing stores, librarians, remain suspicious of the new techniques' ability to retain data and deliver it anew whenever required over very long periods of time: the sort of service provided by printed books aggregated in huge collections in libraries of which university libraries are splendid examples.

Glasgow's library dates back to the foundation but its very first books have disappeared. From the late fifteenth century onwards, however, there is a steady record of acquisition and donation. As late as 1636 it was "a little room not twice so large as my old closet", according to an English visitor. By contrast, the library building erected at Gilmorehill after 1870 was imaginatively satisfying to bibliomaniacs. Its huge steel bookcases rose several floors through successive levels of walkways, like gantries, recalling the mythical library which provides the setting for the dénouement of Michael Innes's thriller, *Operation Pax*. Today's library houses about two million items in a particularly handsome building whose soaring exterior is balanced by the human scale of the floors inside.

The library's glories may be thought to lie in the Special Collections Department but dispersed in the general stacks are many books which should excite interest because of their associations as well as their content. From that very large category, one example must suffice. Between the 1920s and the 1960s the University was privileged to receive an annual flow, often of some hundreds of volumes, from the historian D. W. (later Sir Denis) Brogan.

A prodigious reader who told this writer that he read all night because he could not sleep (and took his typewriter to bed, according to his wife!) Brogan annotated his review copies before writing his pieces and then gave the books themselves to the library. His range was immense, covering the whole field of

Riches tresors; mais tempeste subite

En troublant lair, ceste mer tant irrite

Que la nef hurte vng roc cache soubz l'onde

O grand fortune, o creuecueur trop grief,

De veoir perir en vng moment si brief

La grant richesse a nulle aultre seconde,

CANZONE

Petrarch (The Stirling Maxwell collection)

This copy on vellum of Petrarch's Canzone *is of a French translation by Clement Marot (1496–1544), a court poet of Francis 1. Strictly speaking not itself an emblem book, this manuscript's illustrations are of an emblematic nature and are thought to represent a major root from which emblem books were to spring.*

The title of the French work was Visions de Petrarque. *The "visions" are of a succession of idylls being destroyed by forces of nature. Here a galleon suffers shipwreck.*

This is a manuscript with a long and complex history, Dutch as well as French, and is of particular interest to scholars.

modern affairs, not just the history in which he specialised, with a particular focus on the United States and France. He reviewed for an equally wide range of journals, popular as well as academic, and generations of later students have benefited from his fondness for his *alma mater*. His comments and notes, often covering both sets of end-papers, are sometimes fascinating and useful where his bedtime scrawl can be deciphered! Libraries tend to swallow such material but many users of Glasgow's library will be aware of Brogan's books, which were augmented on his death when his large personal working library was also acquired by purchase.

Of individual books there are numerous rarities to excite the imagination. Any choices, and they must be few, to represent this huge field must inevitably seem idiosyncratic; no doubt anyone with scholarly or visual interests could nominate alternative treasures (maybe in bindings, maybe in Blake items, where the library has two watercolours as well as all the Trianon Press facsimiles of the books). A personal choice would be Audubon and Daniell, both splendid examples of nineteenth-century British illustrated book production and both of some interest to specialist scholars as well as appealing to an enormous general audience.

The Birds of North America is enormous in size as well as reputation. It holds the price record for an illustrated book sold at auction (even to the record for a single page sold separately). Though drawn and partially written by the American, John James Audubon, the book was published in this country between 1827 and 1838, its huge pages being engraved and then individually hand-coloured in Edinburgh and London. The author had been influenced by Alexander Wilson, the Paisley radical and bird illustrator who migrated to the United States for political reasons. That association might explain why the book is so well known in the West of Scotland. As well as the complete set in four elephant volumes at Gilmorehill, there is another in the Mitchell and a third in Paisley (with two illustrations unique to itself). There is a fourth, but incomplete, set in the Royal College of Physicians in Glasgow's St Vincent Street. Protected from infra-red rays in a specially-designed case, this last is the only one on permanent display—a page at a time! The other three can, however, be consulted by anyone with a serious interest.

It is of immense ornithological interest because many of the birds that it illustrated life-size (hence its own enormous pages) are now extinct, but it is also a visual delight with its creatures "looking as if alive" in all their splendid plumage. As with many bird books of the last century it celebrates the union of scientific observation with artistic panache. A great visual delight.

ENGLISH PSALTER, TWELFTH-CENTURY (Ms HUNTER 229)

Produced about 1170 AD, this was one of the treasures of William Hunter's library. It is an example of a small group of surviving twelfth-century English psalters. In spite of the passing of eight centuries, the pages retain the vivid colours of their original state. This particular page illustrates the Ascension.

One volume of Glasgow's set was damaged by damp sometime in the 1940s but hardly seriously. It was purchased as its volumes were published, the library being among the original subscribers. William Daniell's *A Voyage Round the Coasts of Great Britain* was, however, bought long after publication (for just over £400).

Between 1811 and 1823 Daniell spent his summers travelling round the coast of Great Britain armed with little more than a pencil and paper. He then spent the winters drawing and engraving a series of several hundred fine seascapes. (The original plates are now in the Tate Gallery.) Some few are run of the mill but the generality are better than good and some are especially fine, displaying considerable invention and power as well as charm, and recalling some of the best Japanese illustrated books in the fertility of Daniel's mind as well as his skill in execution. The Scottish series are nearly all particularly fine. The engravings were run off and published as an early example of a part series; the complete work has often been called the finest illustrated book of the nineteenth century.

Glasgow's set is one of a small number where the plates were printed directly on to card rather than paper before being hand-coloured (by young girls, paid fifty shillings per hundred, according to one modern researcher).

Although some students believe that as few as twenty-five sets were made in this manner, that is probably an underestimate and no one can be sure: it is certainly very rare. What is especially good about the Glasgow set is that the colours are particularly fresh and attractive, which is not the case with all such examples. What is less happy is that the volumes require rebinding: the Daniell prints were originally published in small gatherings, a few scenes at a time, spanning the years 1811–1823. The library's four volumes were bound later; that they need attention now is hardly surprising. All libraries face enormous problems of conservation but, given the high acid content of papers still favoured by most British publishers, bindings are probably the least of their worries.

One aspect of these, and indeed many of the illustrated books in the library, is that they have become progressively scarcer in our time as individual copies are dismembered and sold off as separate pages for framing and display. This technique yields higher prices to print-sellers than the complete books can command, but its destructive aspect is obvious. (Apart from anything else it usually leaves the individual prints unprotected from the effects of light.)

Of collections of books and manuscripts, there is an embarrassment of riches.

AN ILLUSTRATED BOCCACCIO (Ms HUNTER 208)
The garden of Eden seen here by an unknown fifteenth-century French artist illustrates a French translation of Boccaccio's Tales. The manuscript, which was also in William Hunter's library, contains seventy-eight pictures illustrating various others. What is shown here is actually a carefully executed copy, late-seventeenth or early-eighteenth century, of the original page which was excised (surely deliberately?) earlier. The copy fooled many experts until detailed colour comparisons with those of the other pages disclosed important differences.

De adam et eue premier chapitre commenceant en latin Maiorum nostrorum. et cetera.

Quant ie considere et pense en
diuerses manieres les plouva
bles maleurtez de noz predeces
seurs a celle fin que du grant nom
bre de ceulx qui par fortune ont este
trebuchez ie pensisse au commence
ment de ce liure aulcun prince ter
rien assez digne destre premier entre
les maleureux. Et voicy deux vieil

lare le arresterent deuant moy si tres
eagiez et si ancians quil sembloit quil
ilz ne puissent trahiner les membres
tremblans. Lun de ces deux vieillart
cest assauoir adam me arraisonna et dist
beau nepueu Jehan boccace qui serches
et enquees le quel tu mettes premier
ou reng des maleureux. Je vueil q̃ tu
saiches comme vray est que ainsi coe

The latest catalogue of the Department of Special Collections lists fifty separate major collections. These include the papers of William Cullen, the mentor of both Joseph Black and William Hunter, and friend of Adam Smith. There is a large collection of Trotskiana – a huge holding, donated anonymously in 1983, of printed material (often in first or rare editions) by or about the Russian revolutionary Leon Trotsky. Other holdings of political and religious ephemera include 1,500 pamphlets and several hundred books from the period of the English Civil War. There is also a large collection of material relating to the beginnings of socialist thought in the West of Scotland which, with material in the Mitchell Library, invites research. (For example, together they expose an interesting reverse migration in ideas whereby the New York socialist and "impossibilist", Daniel De Leon, came to command a West of Scotland following.)

Obviously, individual responses to Special Collections will vary. It is impossible to rank such holdings: anything offered here is a fleeting taste. It omits, for example, the library of David Murray, a Glasgow lawyer and bibliophil who died in 1928 – over 30,000 separate entries including 200 manuscripts – all concerned with the history and life of Glasgow and its wide hinterland.

Three holdings may be representative of what is an enormous range of human creativity – the Hunter, Stirling Maxwell and Farmer collections. Hunter amassed over 10,000 printed books and 650 manuscripts. It was an unusually large personal library even in its time, and that it has survived intact confers considerable additional interest. A third of it is unsurprisingly concerned with historical and contemporary medicine; it contains the papers of James Douglas, the distinguished doctor whose anatomical collection Hunter also "inherited ". The rest is wide ranging and serves to illustrate the depth, as well as the breadth, of his interests, reinforcing the opinion that Hunter was more than just a compulsive accumulator. He was somewhat unusual for an eighteenth- (or even nineteenth-) century book collector in not rebinding as much as he could. Lovers of bindings will find that Hunter preserved many fifteenth- and sixteenth-century bindings in his possession, and his fifteenth-century printed books alone total over 1,000. Sir William Stirling Maxwell, however, tended in the opposite direction, though many of his books do also survive in their earliest forms.

Hunter had many splendid medieval and renaissance manuscripts – their

WHEEL BINDING
William Shaw Cathcart, Disputatio Juridica, Edinburgh, 1776
The University library has never collected bindings as such but does have many of considerable interest, particularly in the case of native work. This book is shown here not for its own sake but for its binding which is a striking example of a distinctive Scottish type.
Wheel binding appears to be a descendant of the fan pattern common throughout Europe in the seventeenth century. The pentagram, or Solomon's seal, on each cover is frequently found on Scottish bindings – and may have been put there to hold the powers of evil in check.

splendour deriving from their illumination. The invention of printing ended the laborious work imposed by hand-copying manuscripts but it was not until the nineteenth century that printing techniques allowed the use of colour with anything like the intensity and range achieved centuries earlier. The quality of Victorian colour printing was remarkable. Even now, however, the earlier technique of hand-crafted book decoration and illumination remains unsurpassed in its triumphant excellence; and its productions are all unique works of art.

When the University recently took an exhibition of its early illuminated books and manuscripts to Canada it was, without hyperbole, called "The Glory of the Page". Its accompanying catalogue by Nigel Thorp was richly illustrated by a succession of plates which show how much Hunter contributed: his material

STEAMBOAT ON THE CLYDE NEAR DUMBARTON
from William Daniell's A Voyage Round Great Britain, *London, 1814–25*
This charming print is often thought to be the finest of the 158 (159 if we re-annex Berwick) Scottish scenes Daniell produced. Something of its appeal may result from historical interest since it is the earliest graphic representation of a steamship, in this case the Wellington, *which plied between Dumbarton and Glasgow.*

dominates the catalogue which also discloses how fortunate the University was to have had later benefactors, notably William Euing, a Glasgow insurance broker. His library, within sight of 18,000 separate volumes, came to the university in two separate instalments: the first after his death in 1874 and the second in 1936, when his collection of early printed music was transferred from its original beneficiary, the library of Anderson's College. Hunter's Psalter, now bound in massive wooden boards, and other early items are enthralling but Euing's material adds to their impact.

The library also holds the world's largest collection of one particularly famous kind of early printed illustrated book which has excited much scholarly attention. These are emblem books, illustrated books on a very wide variety of topics but beginning with simple mottoes and images, or emblems, published between

ARDNAMURCHAN
William Daniell
From the same source as the last item, this print is a spirited example of Daniell's ability to catch the wilder aspects of the Scottish seascape – here where the mainland reaches its westernmost point.

the sixteenth and nineteenth centuries, though the main impulse was probably exhausted by 1700. Many have often been republished in facsimile editions in this century when academic interest in them has blossomed, particularly since 1945, both here and especially in Germany.

Emblem books were not simply illustrated books: they cover a range in which words and images were supposed to reflect on each other and be mutually reinforcing, a combination which took the form easily into the realms of religious mystery where imagery is always charged with meaning and words have to carry an unusual burden. The scope for obscurity and intellectual ambiguity is obvious. The form was effortlessly expanded so that it broke beyond any simple definition and came to fill many roles from the erotic to the instructional, even to copybooks.

"The University enters the scene almost as an afterthought," writes one authority on emblem books, of which the library holds a collection probably containing in the region of seventy-two per cent of the titles known to have been published. The afterthought was the codicil to the will of Sir John Stirling Maxwell of Pollok, on the south side of Glasgow, who died in 1956. This allowed Glasgow University to make its choice of any books it wanted from the library of Pollok House: it then acquired about 1,200 of its now internationally famous holdings of emblem books as well as other related items. A policy of constant purchase in this specialised field has augmented that original holding by some 300 titles.

John was the older son of Sir William Stirling Maxwell (1818–1878) who had been born William Stirling but added Maxwell to his name when he inherited the estates and baronetcy of his uncle, Sir John Maxwell of Pollok. Sir William Stirling Maxwell was a politician, historian and art lover who was also an avid collector of emblem books. He loved bindings, putting many of his acquisitions into new ones. Modern scholars groan a little at this habit, for they would always prefer the original format, but in Stirling Maxwell's case it may often have contributed much to preservation. (He also commissioned a remarkable range of book plates to fit his treasures, an aspect of them which is usually ignored because of the greater excitement communicated by their emblematic identity.)

What he eventually accumulated covered the whole field from the very first

EUROPE, A PROPHECY
William Blake, 1794
Blake's rare genius as a highly skilled craftsman as well as a major artist and poet is now universally recognised, though it has taken a long time for his work to have won acceptance.
His illuminated books – in the most precise sense, all his own work – are rare. As well as some proofs, only ten copies of Europe *completed by Blake are known. The copy in the University library is one of two Blake originals which were first loaned, in 1971, and then gifted outright by HM Treasury.*
The library also has copies of all the splendid Trianon Press facsimiles of Blake's illuminated works which copies are themselves among the finest examples of twelfth-century book production.

such books published, Alciato's *Emblematum liber* of 1531, which is available in seventy-six of the 170 or so separate editions known to have appeared. There are many unusual or scarce volumes such as the only emblem book known to have been printed in Armenian. There is also the *Symbola et Emblemata*, an emblematic encyclopedia published in Amsterdam in 1705 at the behest of Peter the Great. This edition is rare because most of it was lost when the ship carrying it was wrecked en route to Russia.

It is a far cry from emblem books, with their appeal to specialist scholarship, to the music hall, with its vastly more popular audience, but a library is by definition a catholic place and one of the University Library's recent personalities made that sort of transition easily. He was Henry George Farmer, who was a worker in the library, a donor himself and a magnet for others to add to the collections.

Farmer was born in Ireland in 1882 where his father was stationed on military service. The family connection and an early aptitude for music explain his first career from the age of fourteen, as a bandsman in the Royal Artillery. He might have settled for this but for a streak of free-thinking radicalism which led him to claim "victimisation", and an inguinal hernia which prevented him from playing the french horn.

The first may have impelled him, the second certainly allowed him, to retire from the Royal Artillery in 1911 and start a second career as a civil musician playing in London theatres and teaching in schools. In 1914 he was appointed Musical Director of the Coliseum Theatre in Glasgow but transferred a few months later to the Empire in which he was to remain until 1947. He formally retired then, only to begin a third, academic, career of which he had given many early intimations. The university benefited most directly from this third stage for, from 1951, he worked part time in the library itself and left voluminous papers there.

Farmer was possessed of an astonishing creative energy. He published his first monograph, *Memoirs of the Royal Artillery Band*, as early as 1904, and went on to produce detailed studies on the history of British martial music and, even

LEONHARD FUCHS (1501–66)

William Hunter's library contained a copy of the famous study of plants by Fuchs, the Bavarian doctor and botanist whose name is more popularly associated with the fuchsia (though that connection was made later as a mark of respect by the French botanist Plumier).

Fuch's book, De Historia Stirpium Commentaril Insignes, was published in Basle in 1542. It is remarkable for more than 500 outline illustrations of plants. These were individually hand-coloured so that copies vary somewhat. Hunter's is a particularly fine example. As well as Fuchs himself, whose portrait here forms the frontispiece, the book also contains portraits of the two artists who made the original drawings and the engraver who reproduced them. The prominence thereby given to these men was an unusual contemporary recognition of their importance to such a work.

more voluminously, on the history of Middle Eastern Arab music and its influence on European music (anticipating in general some of the findings of Leonard Bernstein on such influences on Mahlerian orchestration in particular).

His academic work was, mainly, preceded by a degree in Arabic from Glasgow University in 1924 and a PhD two years later, (both taken through daytime study while engaged in full-time theatre work every evening). He combined this with intense activity in and on behalf of the Musicians Union. He also founded a band, an amateur orchestra, and the Scottish Music Society (in 1936).

Students of Scottish musicology owe much to Farmer's friendships with contemporary Scottish musicians and his advocacy of the library as an archival deposit for their works. Many of the musical collections in its care derive from his activities.

Perhaps one item, in some ways tangential, may illuminate his influence: the library possesses the last letter known to have been written by Mozart, to his wife Konstanze. This letter with other items of Mozartiana was given to the library by Ladislo Zavertal on Farmer's suggestion, their friendship having dated from Farmer's days in the Royal Artillery band of which Zavertal had been director.

A different but equally glamorous clutch of material is embedded in Farmer's theatrical papers including a large number of autographed letters and signed photographs of the famous artistes who performed at the Empire under Farmer's evidently appreciated direction. For those who prefer the reminder of mammon underneath the gloss, there are also three ledgers listing the salaries paid to performers at both the Coliseum and Empire. The Empire's salary books are a must: George Formby got £30 a week in 1911, Vesta Tilley had £200, Harry Lauder £120 but that was before he was topping the bill. In his and Formby's case it is possible to plot the financial success of their careers by the relentlessly upward annual movement in the fee they could command, though neither could match Marie Lloyd who managed to get half the Empire's total weekly takings on one occasion.

It was Farmer's intention to write an autobiography to be called *Tunic, Tinsel, Toga*. It never appeared but ought to attract some young scholar searching for a fascinating theme and an unusual achievement which should be celebrated.

Index

Note: page numbers in *italic* refer to illustrations

Adamson, Robert 73–4
Aepyornis (elephant bird) *84*, 89
Agrippina, on coinage *48*
Alciato, *Emblematum liber* 157
anatomical material 39–44
Anderson, R. G. W. 55, 56
Anderson's College 153
Annan, Thomas 74–80
antelope skulls 89
Antonine Wall: coins 46; distance slabs *18*, 19–28
archaeological material 19–28
Armour, Mary 95, 96
Audubon, John James 146–8

Baillie, Matthew 37
Bannerman, Revd David Douglas 62
Bassett-Lowke, W. J. *121*
Bearsden, Roman remains *20*, *21*, *22*–3
Bearsden shark *25*
beetles *82*, *83*
Bernstein, Leonard 158
Billcliffe, Roger 97, 101
bindings *151*
bird collection 89
Birds of North America, The (Audubon) 146–8
Birnie Philip family 107, 110, 112, *113*–14
Black, Joseph 53–6, *54*, *56*, 150
Blackie, Walter 119
Blackstone Chair 65
Blake, William 146, *155*
blue buck 89
Boccaccio, Giovanni *149*
Boswall, James 36, 59, 129
Boulton, Matthew 133
Boyd Orr Building 15
Boyd Orr, John, 1st Baron 52
Brash, J. C. 131
British coins 46, *50*
British Museum, coin collection 45
Brock, Helen 29, 37, 81
Brogan, Sir Denis W. 143–6
Brougham, Henry 56
Bruce, James *47*, 52
Buckland, William 33
Burke, Edmund 33
Burrell, Sir William 108
Bute Hall 13, *17*
butterflies *88*

cable galvanometer 67
Cadell, F. C. B. 97, 98, 105; *The Red Chair* *99*, 100–1
Cameron, Julia Margaret 80
Cargill, W. A. 92
Carlyle, Thomas 108, 110
Carthage, coins from 46
Cary, Joyce 105
Cassina, Milan 116, *117*
Cathcart, William Shaw *149*
Chalmers, Thomas 74, *75*

Chardin, Jean Baptiste 92
Charlotte, Queen *35*, 85
Checkland, Olive 72
Coats, Thomas 46
Cockburn, Lord 73, 74
coin collections 45–52; British 46, *50*; French 52; Greek 46, *47*, 49; Roman 46, *47*, *48*, 49; Scottish *50*, *51*
Colnaghi Gallery, London 91
Cook, Capt James 33, 85, *134*, 136–42
coral 85
Crawford, Earls of *157*
Cromwell, Oliver 10
Cruickshank, William 37
Cullen, William 27, 53, 55, 150
Cuvier, Léopold 33
Cynethryth, Queen 52

Daly's, Sauchiehall Street 101
Daniell, William 148, *152*, 153
Darwin, Charles 72, 85
David II, King of Scotland *51*, 52
Davidson, Cameron 116, *117*, 120
Davidson, Hamish 116, *117*, 120
Davidson, William 115–16, 119–20
De Historia Stirpium Commentarii Insignes (Fuchs) *158*
De Leon, Daniel 150
deer skulls 89
dental specimens 42–4
Derngate, Northampton *120*
Disputatio Juridica (Cathcart) *149*
Disruption, The 73, 74
distance slabs, Roman *18*, 19–28
Donovan, A. L. 55
Dougan, R. O. 74, 80
Douglas, James 39, 49, 150
Douglas, Margaret 57
Duane, Matthew 49
Dunlop, William 26

Eardley, Joan 96; *Salmon Nets and the Sea* *100*
elephant bird (*aepyornis*) *84*, 89
elk skulls 89
emblem books 153–5
English Civil War, books 150
English psalters *147*, 153
entomological material 85–9
Euing, William, 153

Farmer, Henry George 157–8
Fergusson Foundation 100
Fergusson, J. D. 97, 98; *Les Eus* 96, 100, 101; letters 101; papers 105; *Royan* 100; *Woman, Flowers and Fruit* 100
Fergusson, Sir James 105
Florentine Terrace (later Southpark Avenue), Mackintosh house in 115–19
Formby, George 158
fossils *25*, 26
Fothergill, John 85
Foulis Brothers 91

Free Church of Scotland, foundation (1843) 73–4
Freer, C. L. 108
Fuchs, Leonhard 157
Gabon beetle (*Goliathus goliatus*) *83*
Galbraith, J. K. 27
George IV, King of England 45
Gibbon, Edward 33
Gillies, Sir William 96
Gilmorehill site 10, 13–18, 39, 45
Glaister, John 131
"Glasgow Boys" 108
Glasgow Herald 101–5
Glasgow, Japanese connection 72
Glasgow University, foundation and growth 9–18; departments, *see* under individual names
Gravid Uterus, human *36*, *38*
Guiness Book of Records 70
Guthrie, James 108

Haddow, Alexander *86*
Hadrian's Wall 19, 20
Hamilton, Gavin: *Abdication of Mary Queen of Scots* 90
Hamilton, Sir William 49
harmonic analyser 70
Heggie, James 133
Henry, George: *River Landscape by Moonlight* *93*
Hepburn, Charles 92
Hess coin collection 49
High Street site 10, 13
Hill Adamson photographs 73–4, *75*, *76*, 77
Hill, David Octavius 73–4
Hill House (Helensburgh) 116, *119*
Hillhead site 15
Hiroshige: *Station No. 2. Kawasaki* 101
Hokusai, Katsushika 113–14; *Great Pine Tree at Aoyama* *113*
Hooper, James 136, 142
Hornel, Edward *93*
Howarth, Thomas *124*
Hughes, T. Harold *12*
Hume, David 59, 60
Hunter, G. L. 96; *Venice* 97
Hunter, James 27
Hunter, John 27, 29, 33, *34*, 36, 37, 39, 85 136
Hunter, William 27–37, *28*, 150; anatomical and pathological material 39–44; books 146, 148, 150–3; coins 45; ethnographic material 136–42; paintings 91–2; silver 129, 131, 132; zoological material 81–5
Hunterian Art Gallery 12, 18, 91–106, 107–14, 115–25; doors 92; Mackintosh house 115
Hunterian Museum 44, 45, 57, 139
Hutcheson Hill, Bearsden, distance slab *20*, *21*, *22*–3

Innes, Gilbert 100
insects 85–9

James, Henry 107
James V, King of Scotland *50*
Japan, connection with Glasgow 72
jaw and teeth, human *43*
Johnson, Samuel 37, 57, 129

Kandinsky, Vassily: *Composition V from
 Small Worlds 104*
kayak, scale model *139*
Kelvin & White *64*
Kelvin, William Thomson, 1st Baron *14*,
 63–72
Keppie, Lawrence 26
King, J. J. F. X. 85
Klee, Paul: *Hofmansche Szene 102*
Koninck, Philips de 92; *Panoramic
 Landscape 32*, 92

laissez-faire economy 62
Laskey, Capt John 139–42
Lauder, Harry 160
Lavery, Sir John 97, 108
Leyland, F. R. 110
Library *12*, 15, 143–60; Special
 Collections 148–59
Lincoln, Abraham 80
Lion and Unicorn staircase 10, *15*
Lister, Sir Joseph 44
Lockie, J. R. 46

McBey, James 114
MacCulloch, Horatio 96
MacDonald, Margaret *108*, 115; *Summer
 125*
Macdonald, Sir George 37
mace, university 9–10, *128* 129
McFarlan, Principal 13
Macfie, Alec 94–7
Macfie, John 94
Mackay, John 133
Mackenzie, Sir Compton 129
Mackintosh, Charles Rennie 18, 115–21;
 flower paintings 121; house 115–19,
 116, *117*, *118*; *Larkspur 123*; letters
 101; *Little Bay 124*; *Rose-bay Willowherb
 126*; *Scottish Musical Review* poster *127*;
 Tulip and Lattice 122
MacNair, Sylvan *121*
MacNicol, Ian 95
McTaggart, William 97; *Fischer's Landing
 94*
Mair, (Major), John 10
Maori material *134*, *136*, 142
mariner's compass *64*, 72
Maxwell, James Clark 70
Maxwell, Sir John 154
Maxwell, Sir William, see Stirling
 Maxwell
medals and medallions 52
Melanesian material 142
Melville, Andrew 10; *Byway in Granada
 95*
"mermaid" *40*, *41*
Meulendijk Tribal Art collection 136
monkeys *86*
Morehead, Alan 135
Morris, May 105
Mozart, Wolfgang Amadeus 158
Muirhead, Lockhart 133
Munch, Edward: *Man's Brain 103*

Murphy, Henry George 133
Murray, David 150
Murry, John Middleton 105

Nero, on coinage *48*
Newhaven ladies 74, *77*
Nootka Sound indians *134*, *141*, *142*

Opie, Iona 133
Opie, Peter 133
Orange, Frederick Henry, Prince of *31*
Oxford, Robert Harley, Earl of 49
Oxford University coin collection 45

paintings 91–106, 107–14, 121
Paolozzi, Sir Eduardo 92
Papal medals 52
Papua New Guinea 135
Park, Stuart 97
Parkinson, Sydney 85
pathological material 39–44
Pearce Lodge 10
Peploe, S. J. 97, 98; *Ben More, Mull 98*
Petrarch: *Canzone 144–5*
photographs 73–80
Physics Department 14, 69
pitch glacier *68*, 70
Polynesian material 142
psalters, English *147*, 153
Ptolemaic head *47*
Punic coin, Roman *47*
Purgatory box 69

Raeburn, Sir Henry: Joseph Black
 portrait *54*
Ramsay, Allan: William Hunter portrait
 28, 91–2
Randolph Hall 13
Reading Room *12*, 15
Regnault, Victor 65
Reid, Alexander 108
Rembrandt van Rijn 37, 91, 92;
 The Entombment 30–1, 33
Reston, David Douglas, Lord 62
Rickey, George: *Three Squares Gyratory* 92
Riddell, William *15*
Robertson, Pamela 121
Robertson, Patrick 131
Roman remains 19–28; brothel tokens
 46; coins 46, *47*, *48*, 49; distance
 slabs *18*, 19–28
Rothenstein, William: Lord Kelvin
 portrait *71*
Rothko, Mark 114
Rowlandson, Thomas 37
Royal Infirmary, Glasgow 39, 42
Ruskin, John 73, 112
Ruxton murder case 131–3

Sadler coin collection 49
Scott, Sir George Gilbert 10, *11*, 13, *15*
Scottish art 91, 94–105
Scottish coins 50, *51*, 52
Scottish Colourists 96–105
Scottish Musical Review 127
Scottish Universities Inquiry Commission
 (1878) 45
sculpture 92
shells 85
silver *61*, 129–33
Smillie collection 92

Smith, Adam 27, 33, 57–62, 131, 150
Smith, Archibald *64*
Smith, George 100
Smith, Sabina *64*
Southpark Avenue, Mackintosh house
 115–19
spintriae *51*
stained-glass window *16–17*
Stirling Maxwell, Sir John 154
Stirling Maxwell, Sir William 150,
 154–9
Strethcanthus 25
Stubbs, george 29, 92; *The Moose 34*;
 The Nylghau 35
Stubbs paintings 29
Swift, John 131, *132*
Symbola et Emblemata 157

Tahiti stone adze *140*
Talbot, Henry Fox 73, 74
Tassie, James 57, *58*
tetradrachm *47*
Theory of Moral Sentiments (Smith) 59, 60
Thomas, Sir Patrick Muirhead 133
Thomson, Alexander "Greek" 18
Thomson, James (Kelvin's brother) 70
Thomson, James (Kelvin's father) 63–5
Thomson, William, see Kelvin
Thorp, Nigel 152
Thylacine wolf *87*
Tilley, Vesta 160
Tongan cloth *137*, *138*
Trans-Atlantic Cable Project (1866) *66*,
 70, 72
Tripe, Linnaeus 80
Trotsky, Leon 150
Turnbull, William, Bishop of Glasgow 9
Turner, Revd George 142

Universities Commission Report (1858) 45

Van Rymsdyk, Jan 36, *38*
*Voyage Round the Coasts of Great Britain,
 A* (Daniell) 148, 152, *153*

Walpole, Horace 33, 36
Watt, James 53–5, *56*
Waugh, D. S. R, *12*
Wealth of Nations, The (Smith) 59, 60,
 62, 131
Welsh, David 76
wheel binding *151*
Whistler, Beatrix 106, 107, 113–14
Whistler, James Abbott MacNeill 91, 92,
 107–14, 115; *The Arabian 112*; etchings
 112; *Grey and Silver: The Thames 111*;
 Harmony in Red: Lamplight (Beatrix
 Whistler) *106*; "nocturnes" 110, 112;
 pastels 110–12; Peacock Room 110;
 Princesse du Pays de la Porcelain 108;
 Self-Portrait 109
Whitehead, P. J. P. 85
Whitfield, William *12*
Williams, Lady (Joan) 129, 133
Wilson, Alexander 146
Windyhill, Kilmacolm 119

Young, Andrew McLaren 91, 110

Zavertal, Ladislo 158
zoological material 81–9
Zoology Department 15, 81: Museum *80*

160